For Liz —

Thank you for being such
a wonderful supporter Liz!

Xo [signature] 2014

MARC OHREM-LECLEF
OLYMPIC FAVELA

Texts by
Itamar Silva and Luis Pérez-Oramas

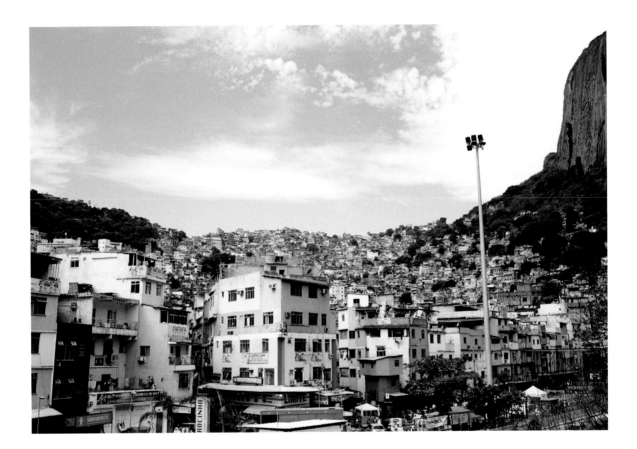

To the many generous people I have met on the hills and in the flatlands of Rio de Janeiro,
for showing me the heart and soul of their city.

[DAMIANI]

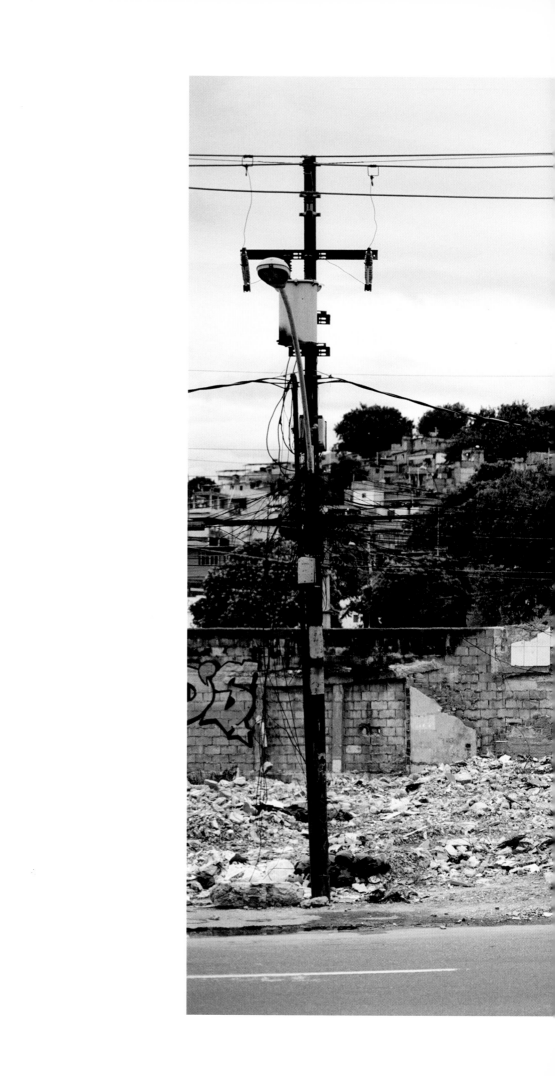

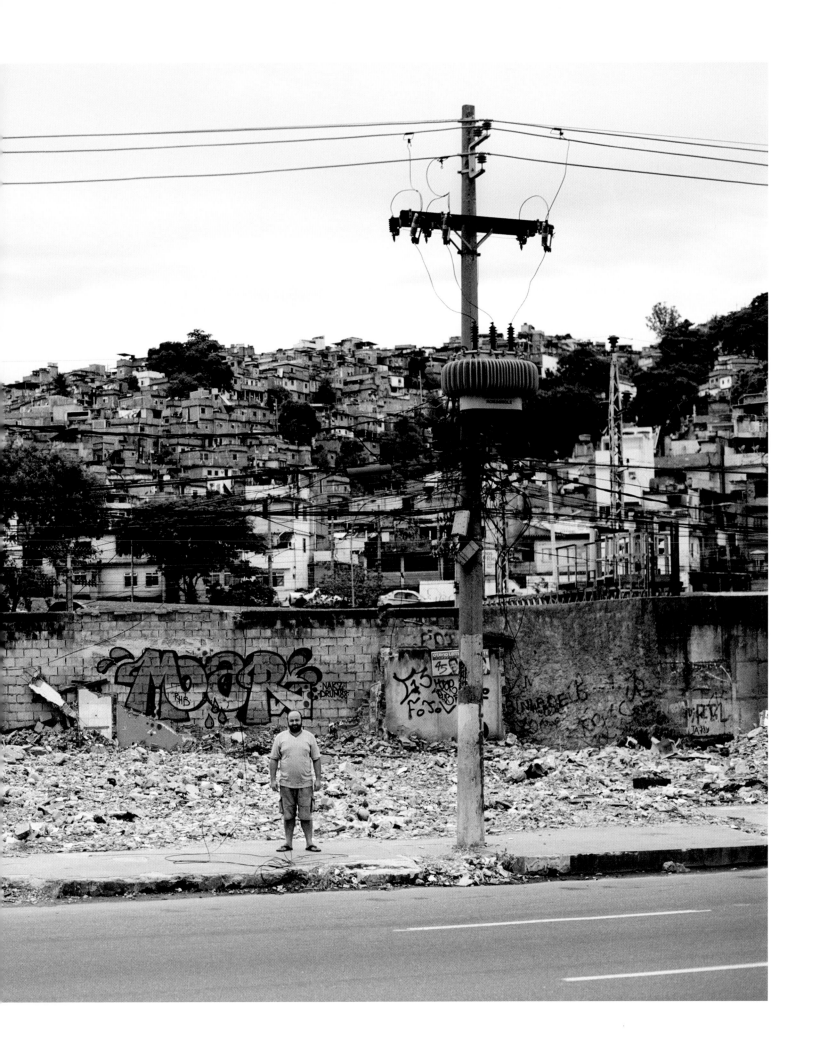

OLYMPIC FAVELA — "VAI COM DEUS"

Marc Ohrem-Leclef

Approximately 1.4 million people live in Rio de Janeiro's favelas.

In many of these favelas, the city's housing authority *Secretaria Municipal de Habitação*, in short SMH, has been systematically evicting people in an effort to reshape the urban landscape in anticipation of the World Cup in 2014 and the 2016 Olympic Games. Families are removed from their homes—often with little notice and with use of force—and homes are demolished immediately after.

In my work I have long been drawn to examine the fabric of different communities, as well as the intricate bonds an individual forms with a community and how these bonds manifest themselves in their interactions with others. When I began my work on OLYMPIC FAVELA, I became especially interested in these aspects surrounding community: One's ties to his or her environment, mobility in relation to wealth and class, forms of communication and the influence of individual, familial and collective memory—and how all these elements are subject to a state of constant flux.

In autumn of 2012 I set out to portray the people directly and indirectly affected by the SMH's policies of systematic removal, with the help of a number of residents who had begun to organize their communities to resist the evictions. I returned to the city early in the summer of 2013 to continue this work, shortly before widespread protests erupted against the government's spending in preparation for the World Cup and the Olympics. With my guide *Café*, an aspiring filmmaker from Rio, I met residents in 13 of the city's favelas—communities both welcoming and with an omnipresent hue of danger—who shared their stories with us:

Suzana lives with her two sons and partner in a house perched on the smooth boulders high above Ipanema, in Favela Cantagalo. In their quest to bring *Suzana* to abandon the home she built, city officials had threatened her with the removal of her children, arguing that they are not growing up in a safe environment. (Pages 8, 29, 31)
After a long career as a seamstress at the municipal theatre of Rio, *Vò Zeze* built a spacious home in the community of Colônia J. Moreira in the city's West Zone. The beautiful home and garden she spent years building now lie directly in the path of the planned TransOlympic Highway. (Pages 55, 57)
Ricardo from Laboriaux, the city-facing side of Rocinha, told us how the government is paying off individual families to leave their homes with stunning views across Rio's Lagoa neighborhood and city beaches, breaking up the longstanding neighborhood bit by bit with the demolition of each home. (Page 76)
Seu Barrão and his son *Tiago* posed for me on their boat in the expansive waters of the Lagoa de Jacarepagùa, close to their home in Favela Vila Autodromo. A fisherman, *Seu Barrão* fears the loss of his livelihood if he is forced to relocate to a remote area, as has been projected by the city planners. (Pages 48, 51)
I first photographed *Eomar* in front of his home in Favela do Metrô in 2012. His was a lone four-story building standing amidst the rubble left behind following the demolition of his neighbor's homes. When I returned in 2013, I photographed him in the same location—with his home gone. (Pages 2, 5)

The works in OLYMPIC FAVELA create a canvas portraying those who choose to stay and defend their home in the face of great adversity and state power. In an effort to call attention to the specific circumstances at play in Rio de Janeiro, I have created two parallel bodies of work:
One group of images consists of portraits of the people who live in the favelas, the people who make them the vibrant neighborhoods they are. Many of the residents are photographed in front of their homes, which have been designated for removal by SMH with spray-painted code numbers.
The second group features directed images of residents posing with flaming emergency torches in their communities. Referencing iconic imagery ranging from Delacroix's 'Liberty Leading the People' and Bartholdi's 'Liberty Enlightening the World' to news imagery of the Arab Spring, these photographs invoke ideas of liberation, independence, resistance, protest and crisis, whilst making use of the core symbol of the Olympic Games—the torch.

Together with the portraits, these images juxtapose the dynamics of celebration and togetherness with those of struggle based on social-economic disparity, which the mega-events are bringing to Rio de Janeiro and its citizens. The people I met face extraordinary challenges: city officials who use ever-changing tactics to sow fear and insecurity to actively erode the sense of community; and lengthy, complicated legal disputes they must wage to avoid eviction and assert their rights to remain in the homes where they have grown up. Their firsthand accounts of their uphill battle, of the perseverance and ingenuity they employed to build their homes, and of the history of their communities—many residents we spoke with are third-generation residents of their neighborhoods—revealed the full breadth of their fears and underlined the need for their voices to be heard.

Yet—after spending time together, when it was time to move on, always came the words, spoken softly and with great sincerity:
"Vai com Deus." Their well-wishing goodbye stuck with me, for in that moment, with *them* wishing *me* luck, a reversal of roles played out that highlighted the broader experience I had: Despite their incredibly difficult circumstances, the residents of the favelas retain a deep-seated optimism and generosity—and a sense of hope that their place in Rio will be respected.

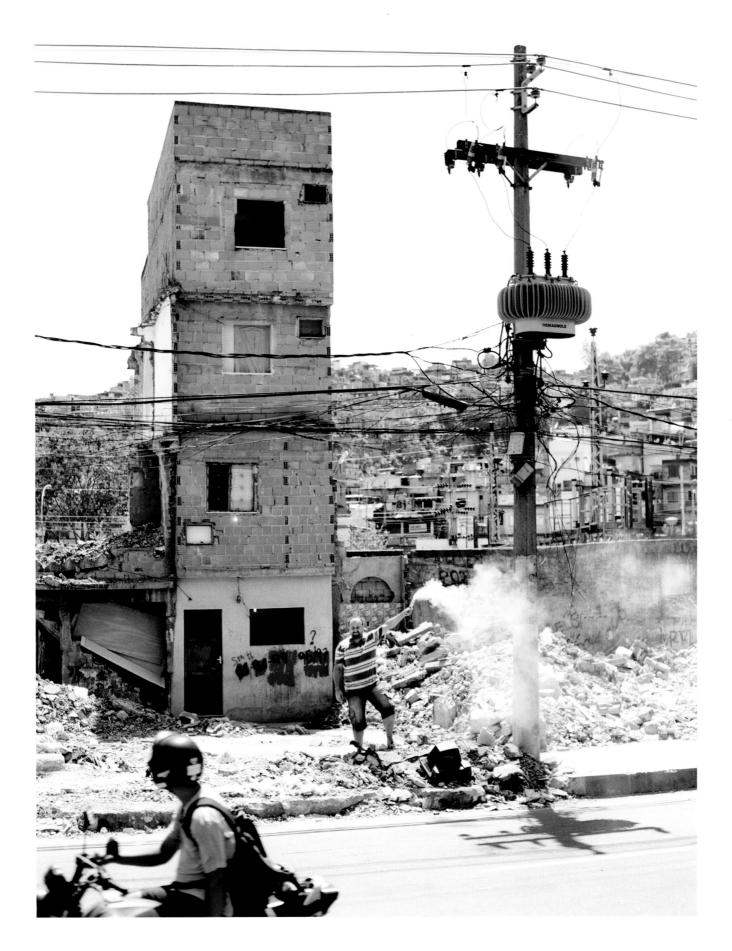

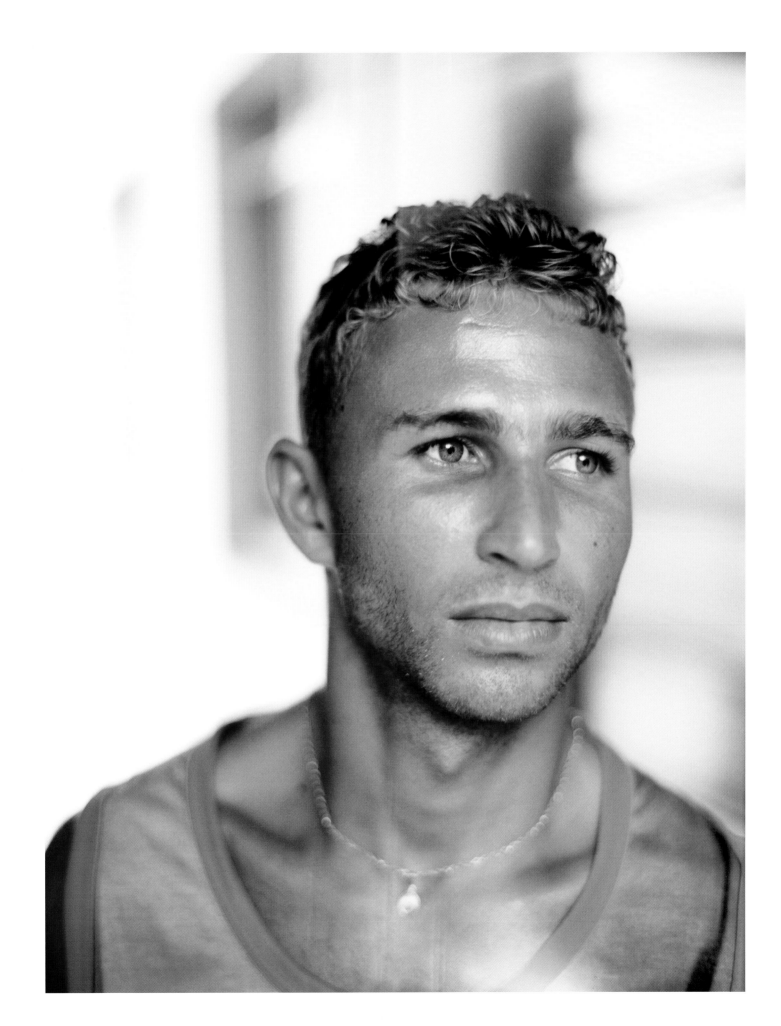

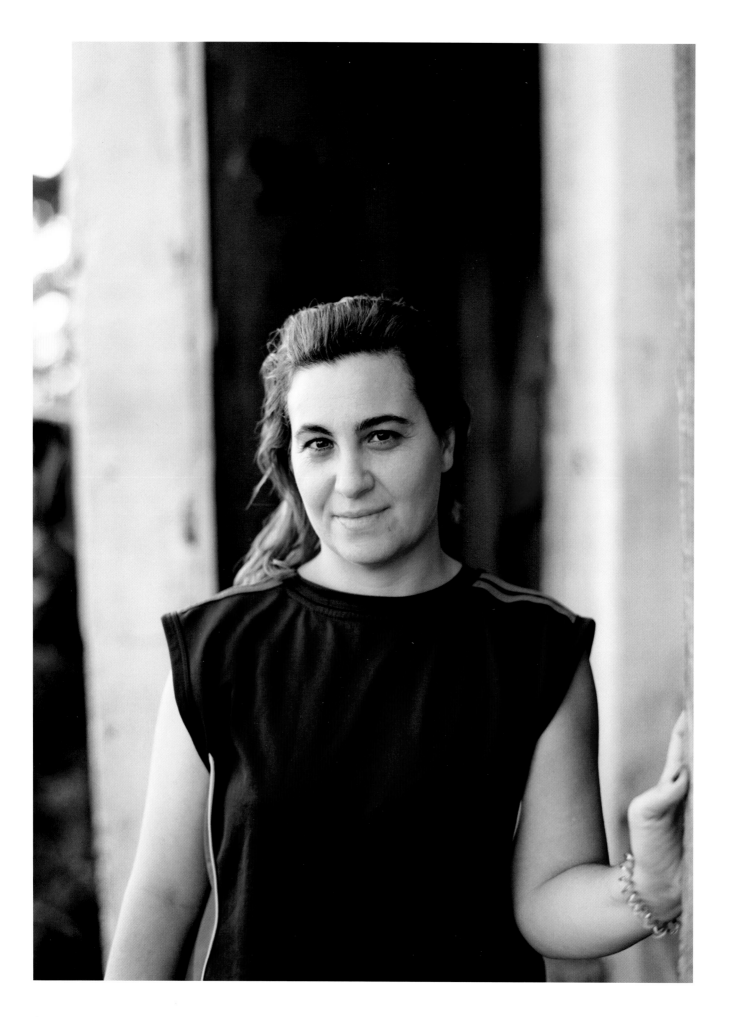

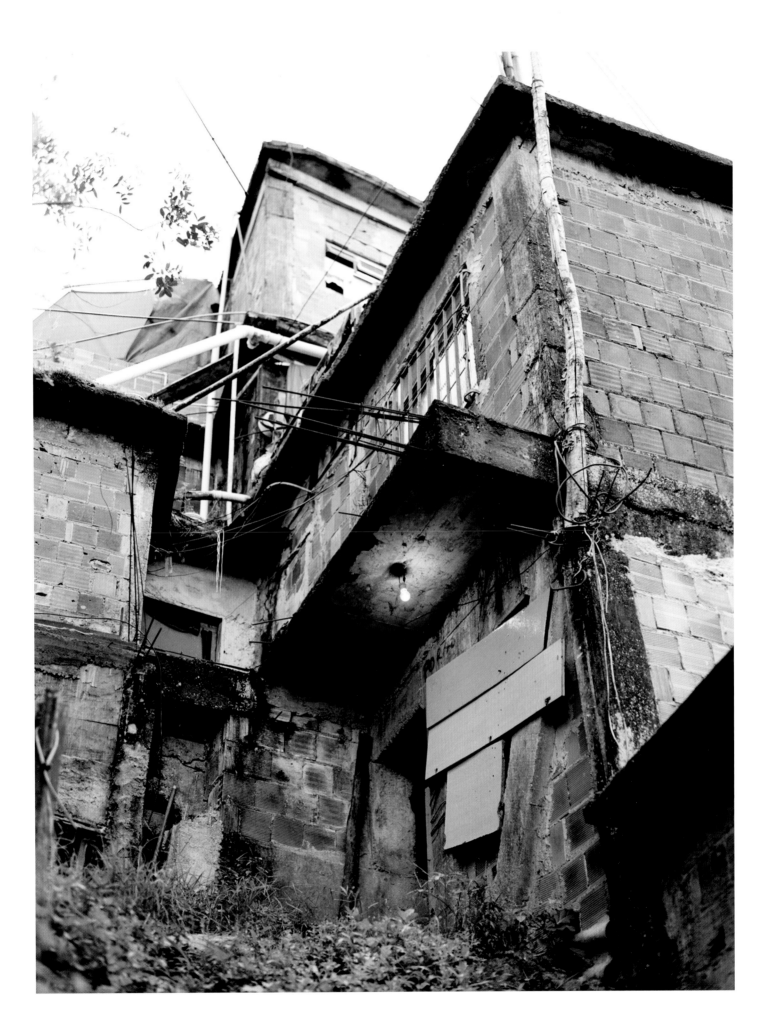

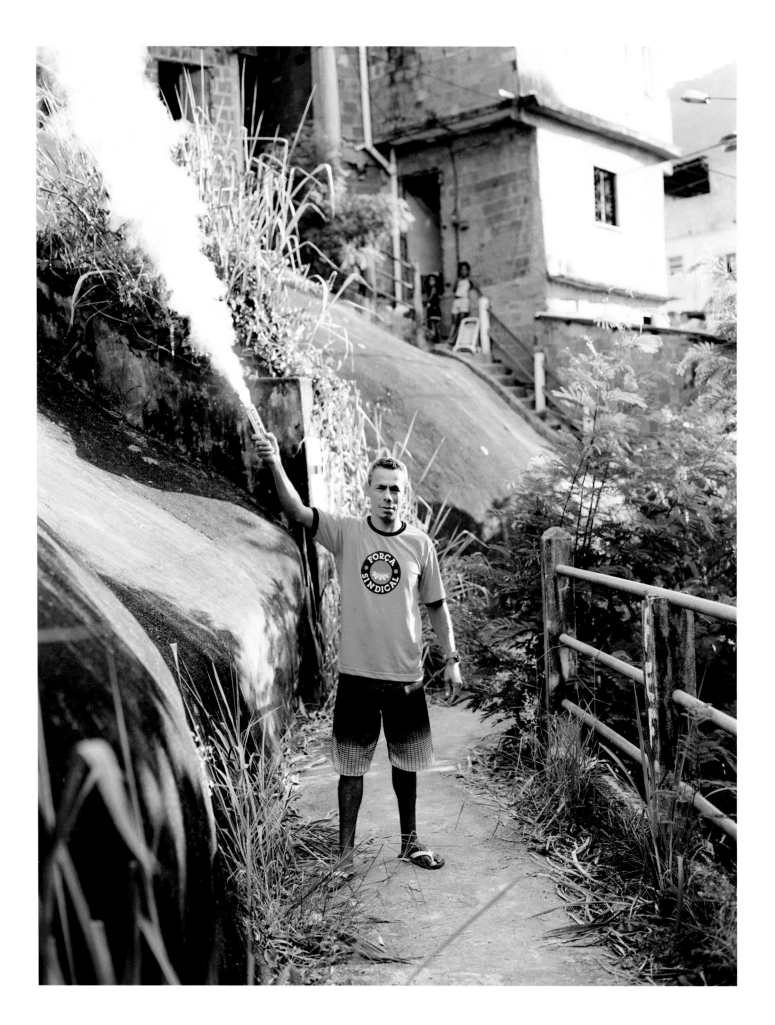

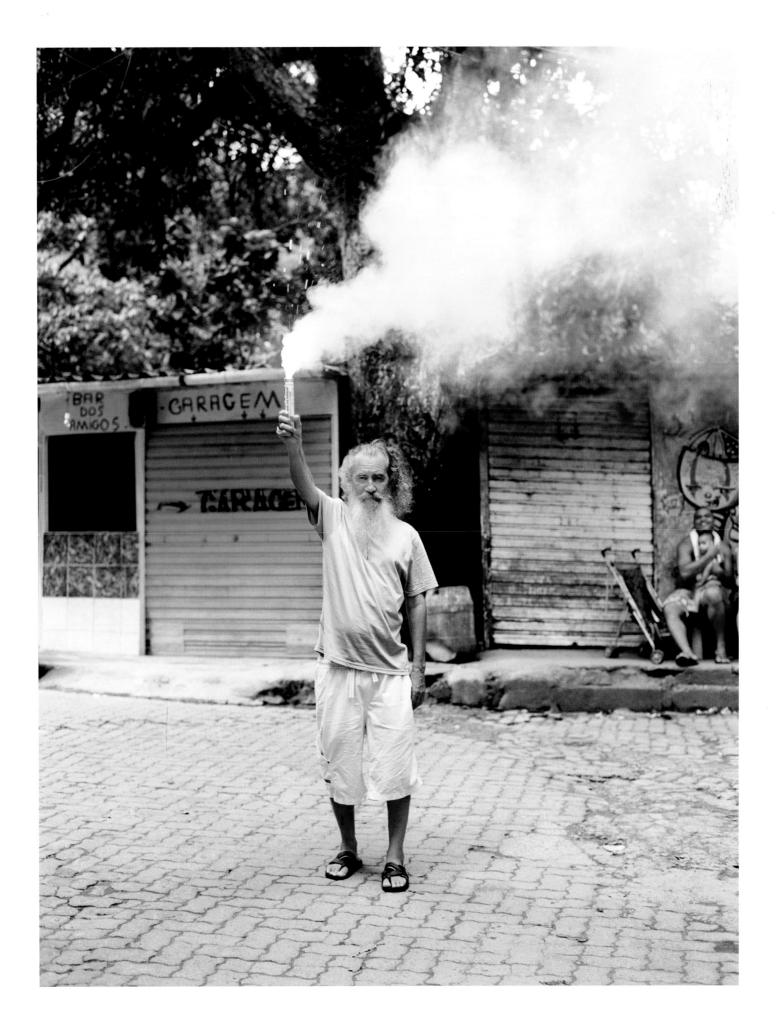

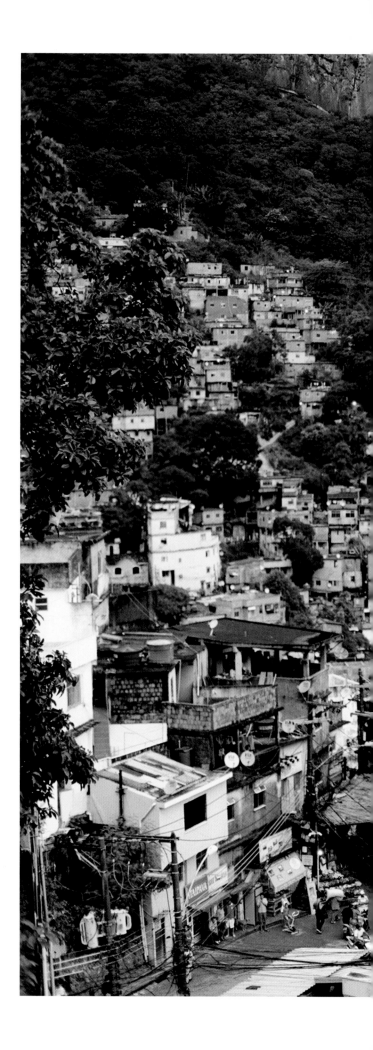

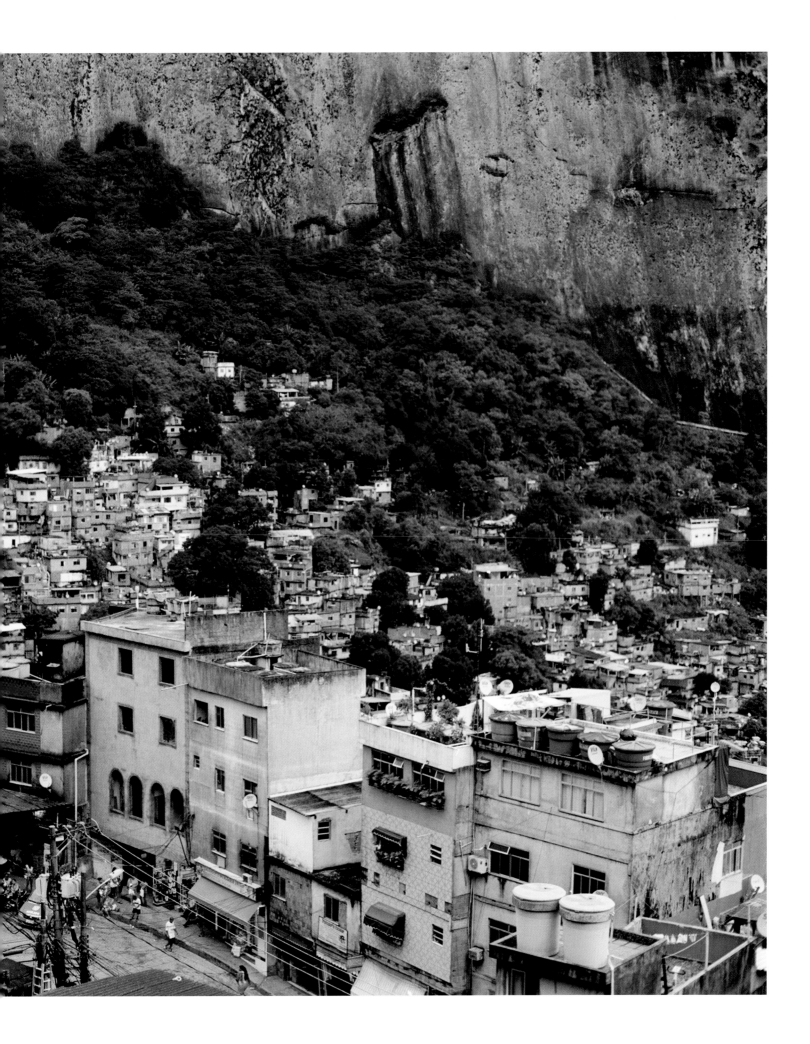

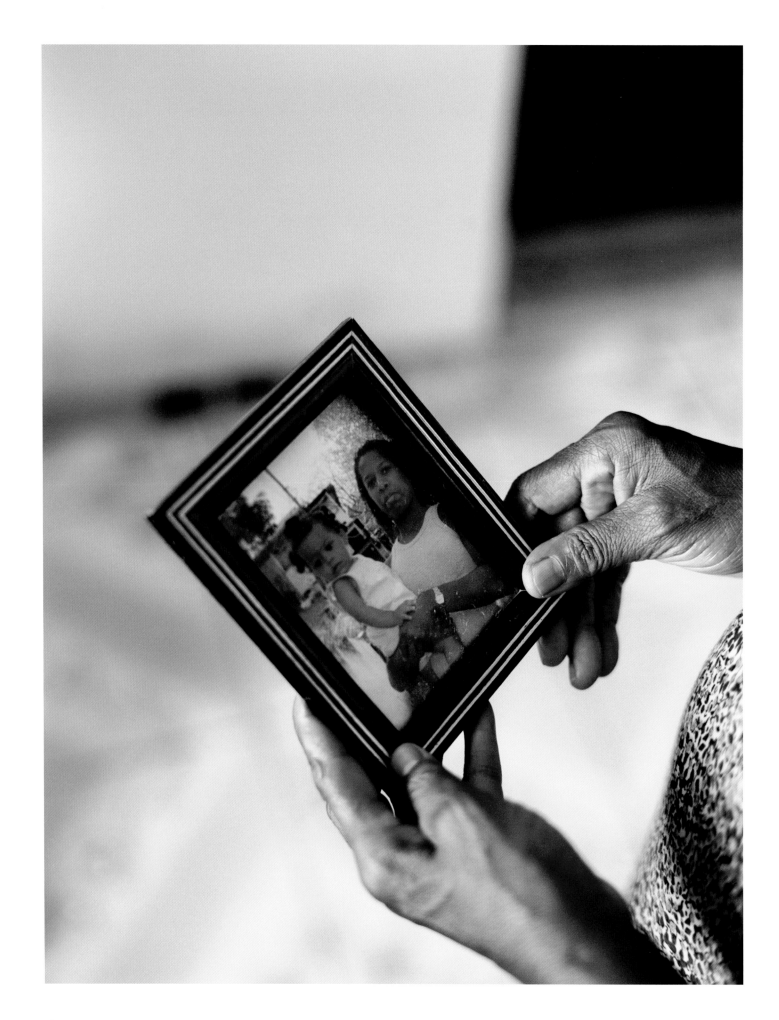

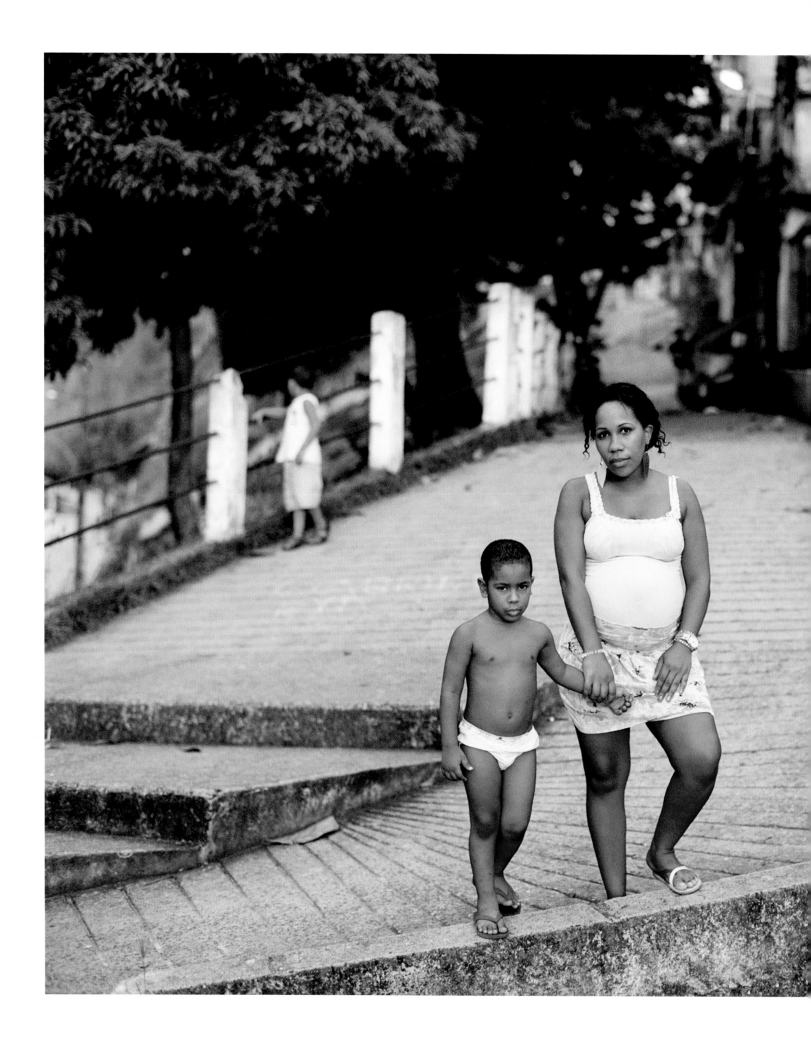

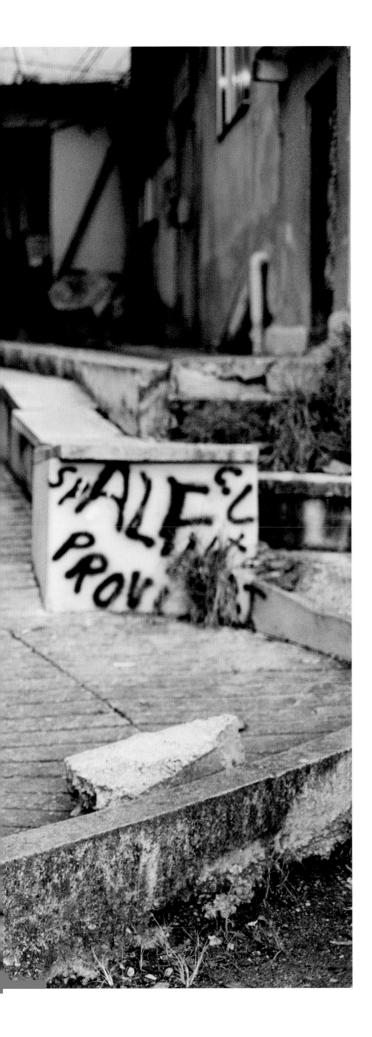

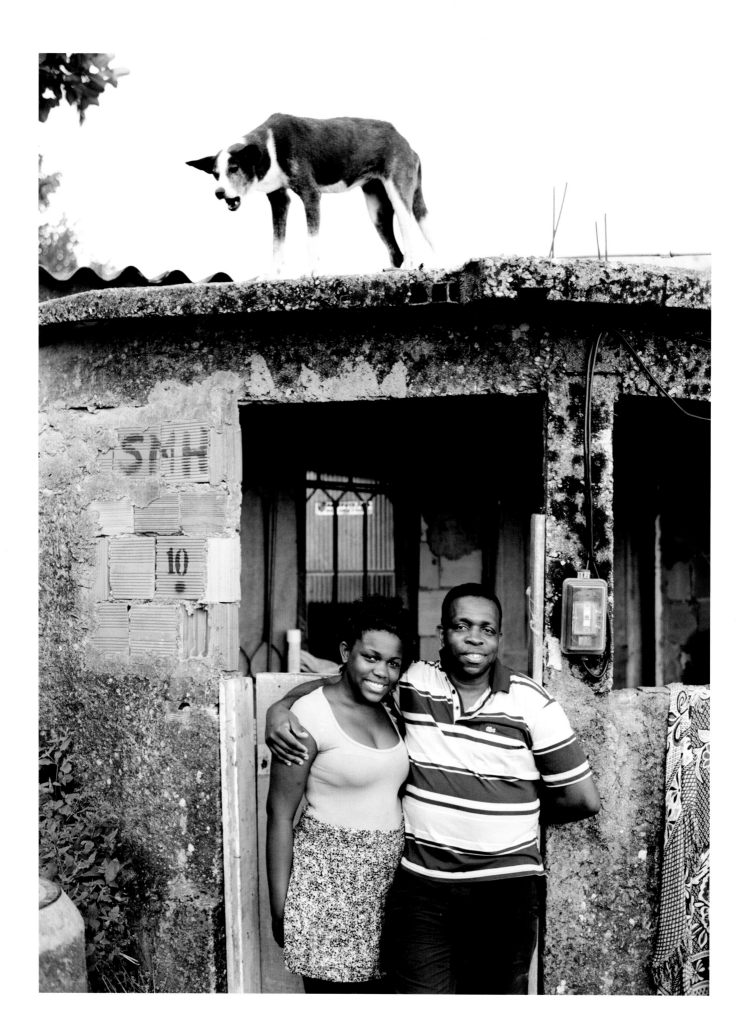

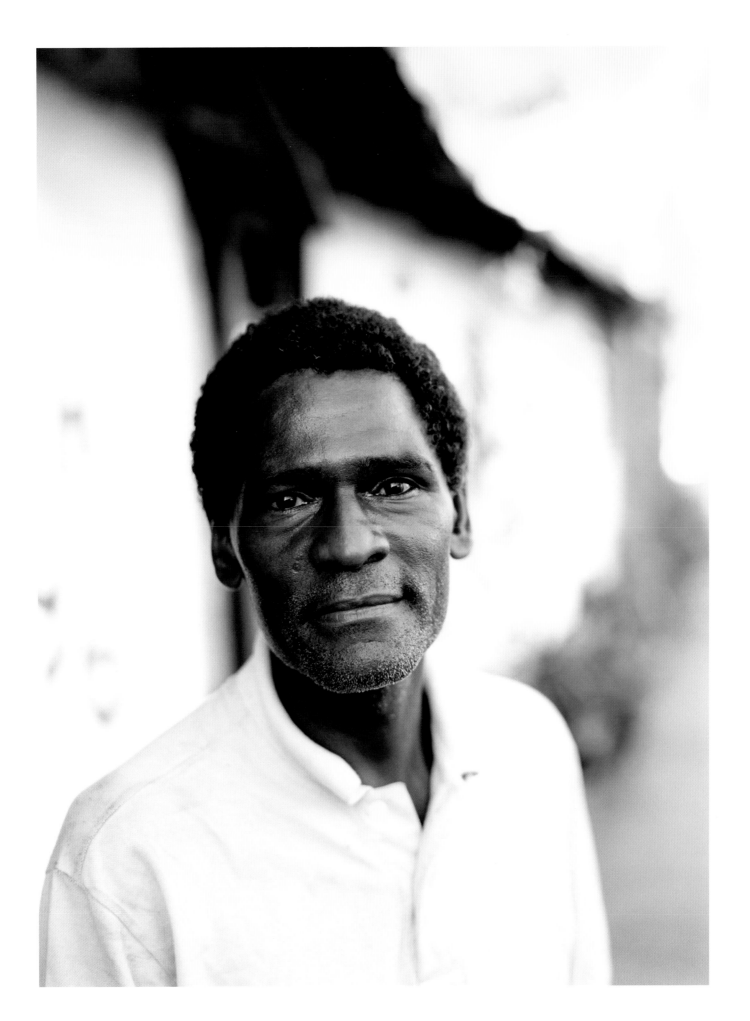

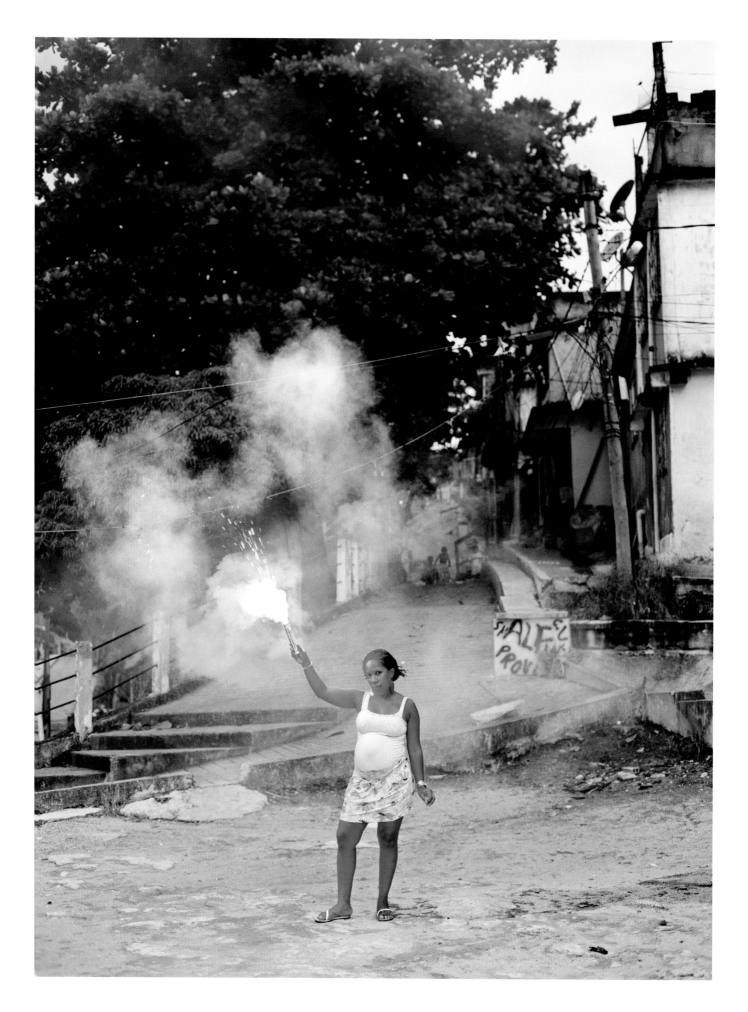

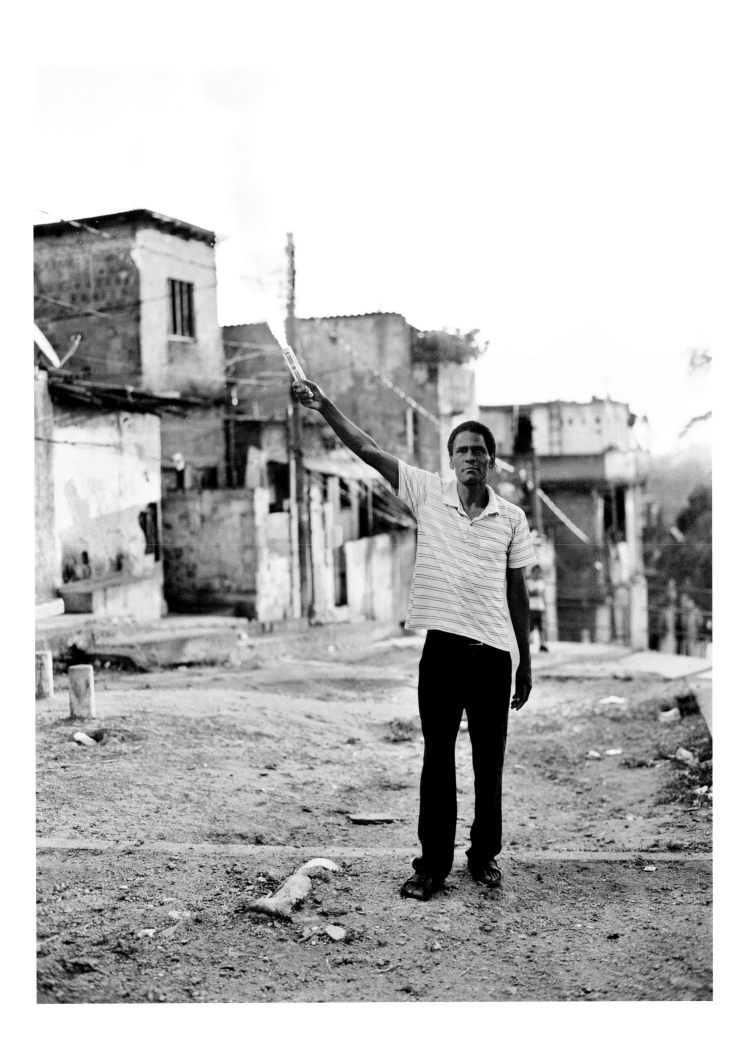

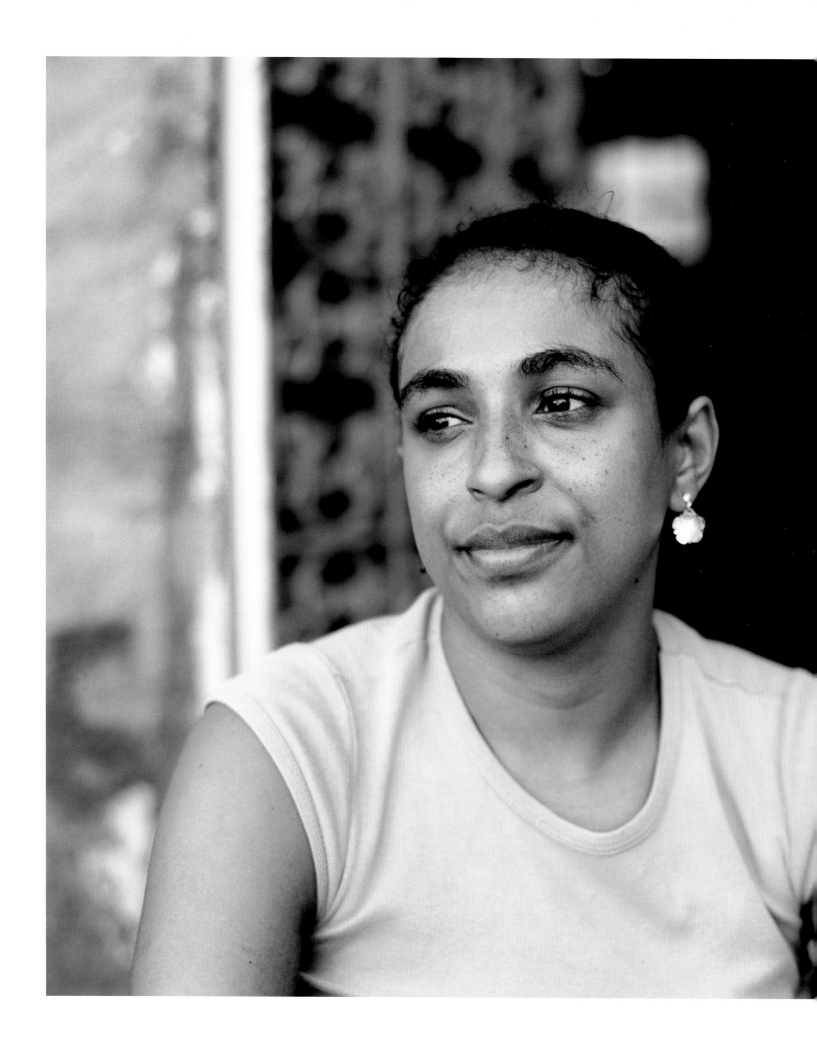

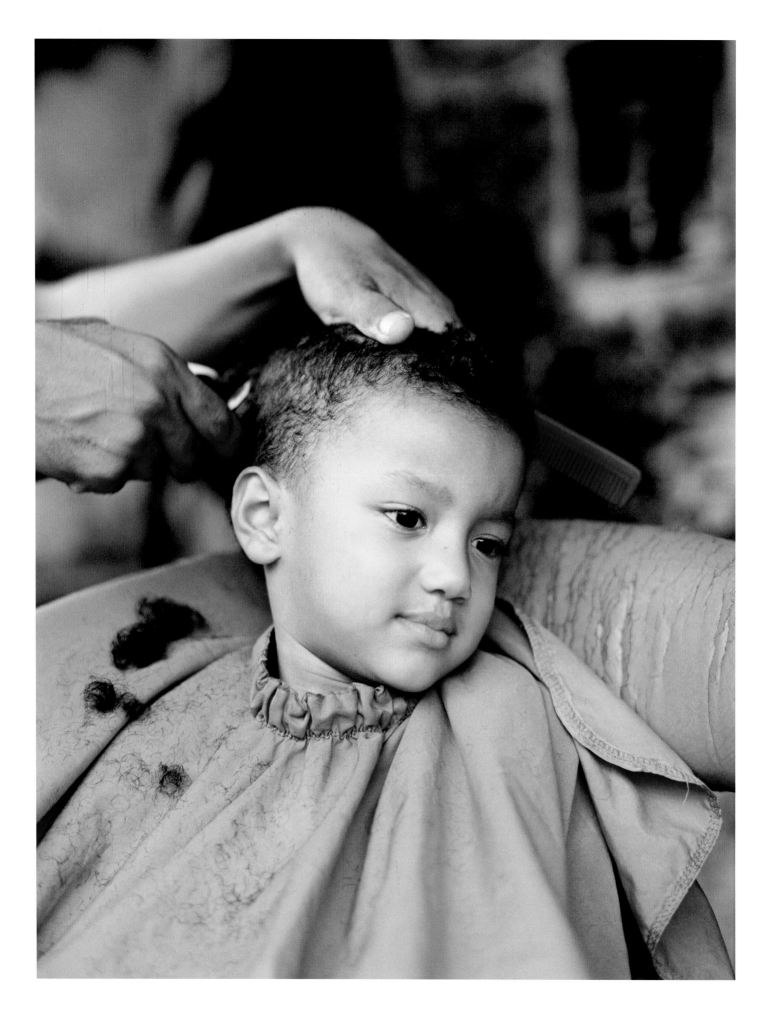

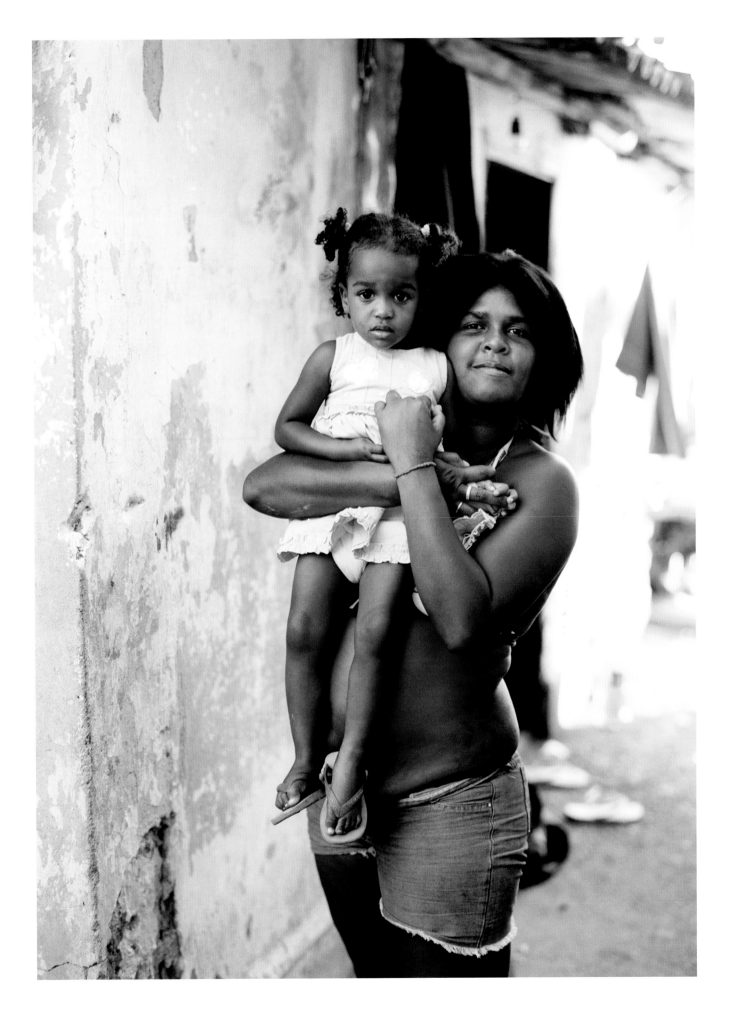

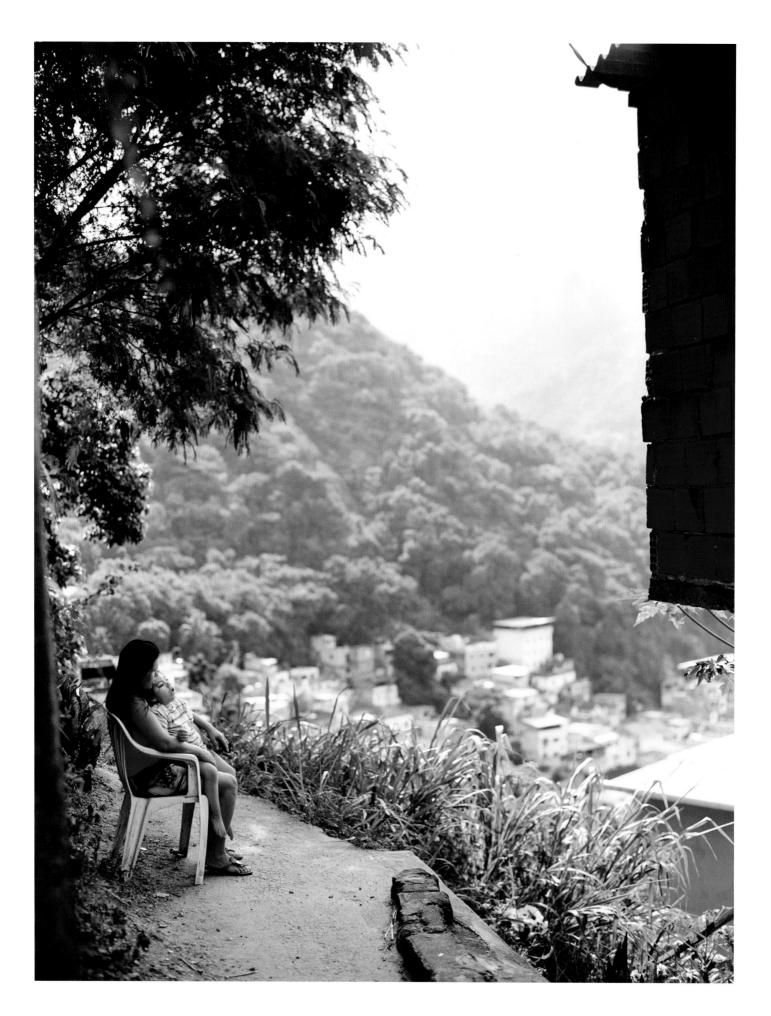

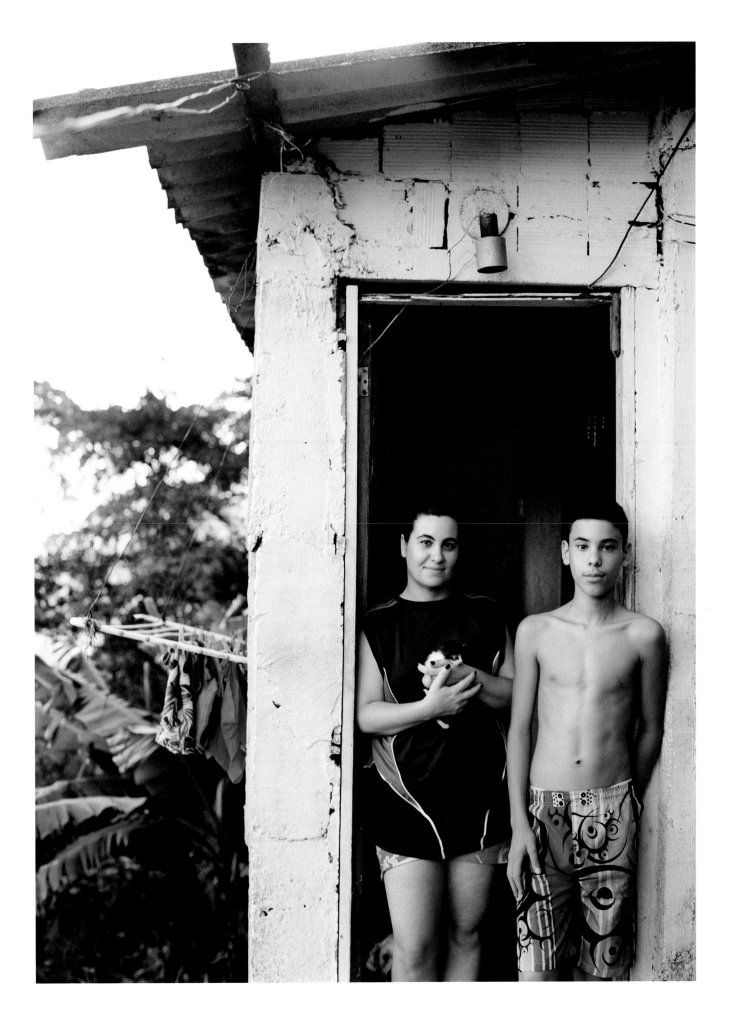

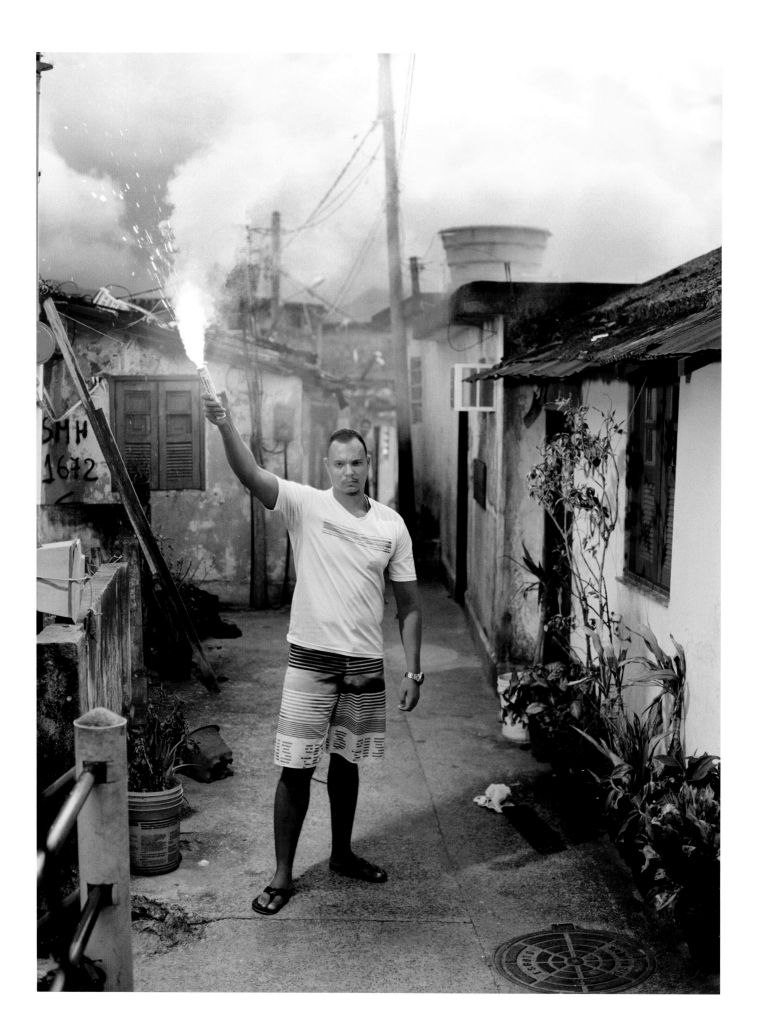

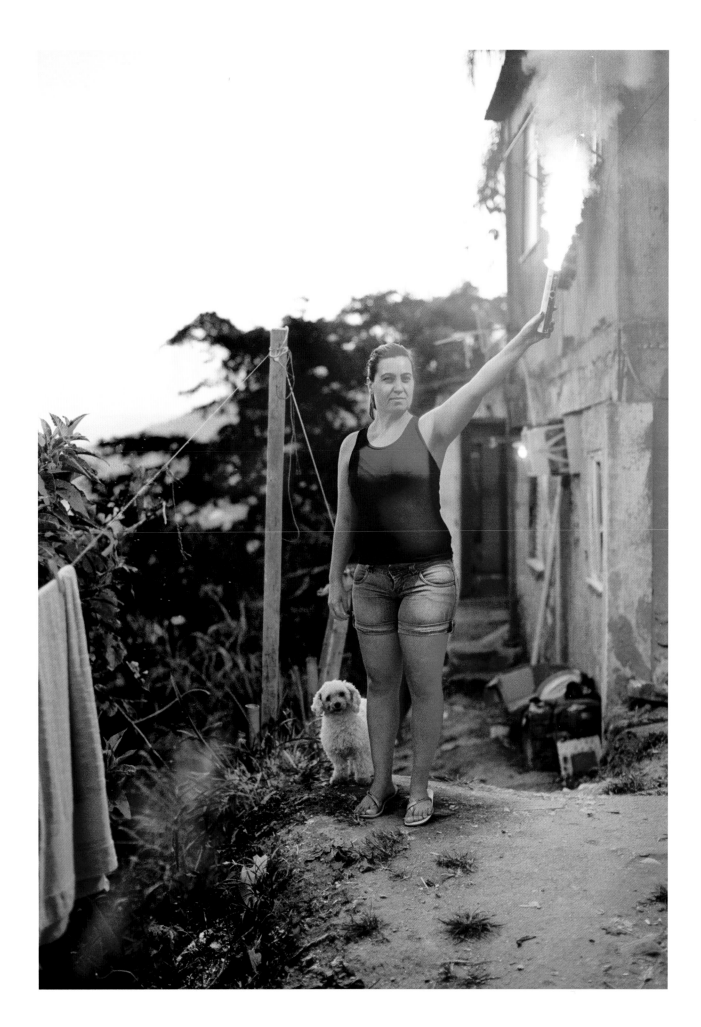

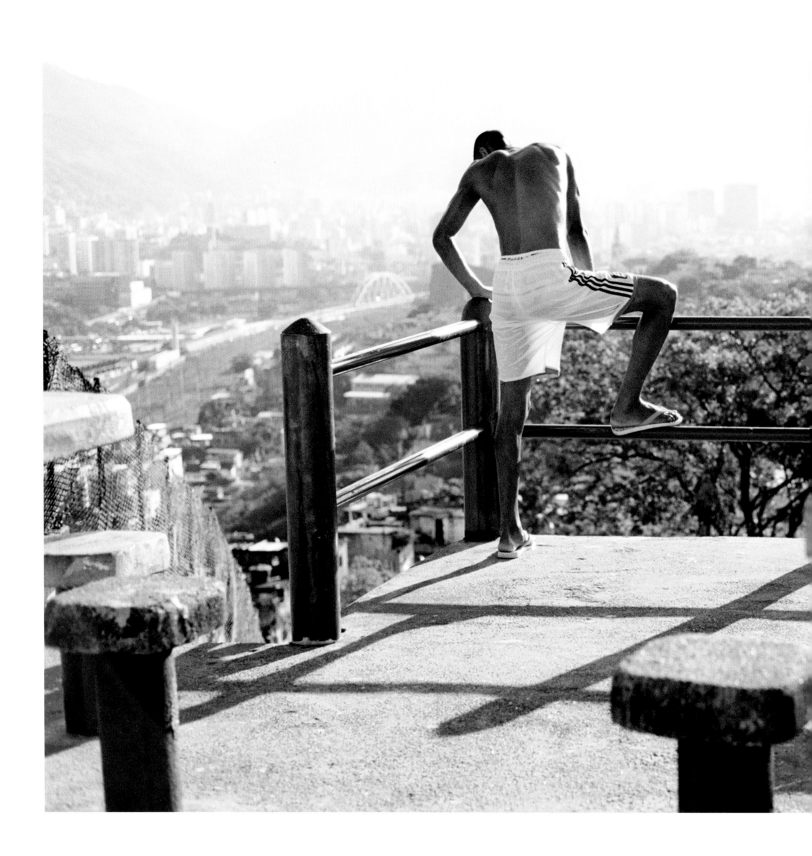

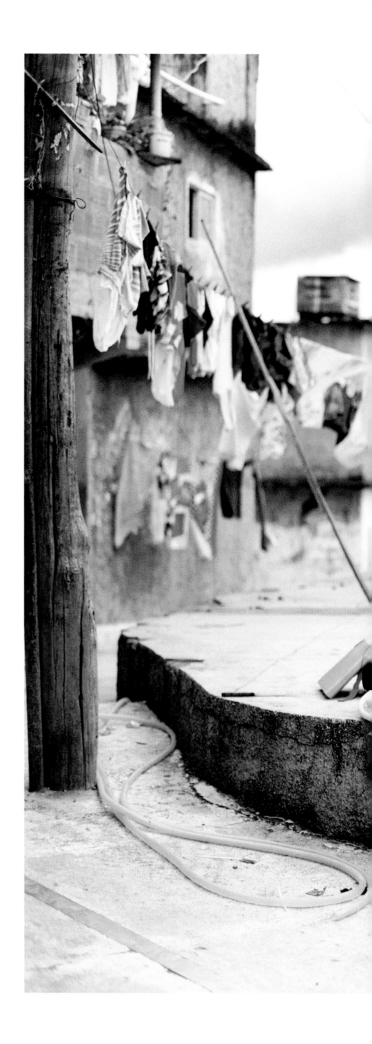

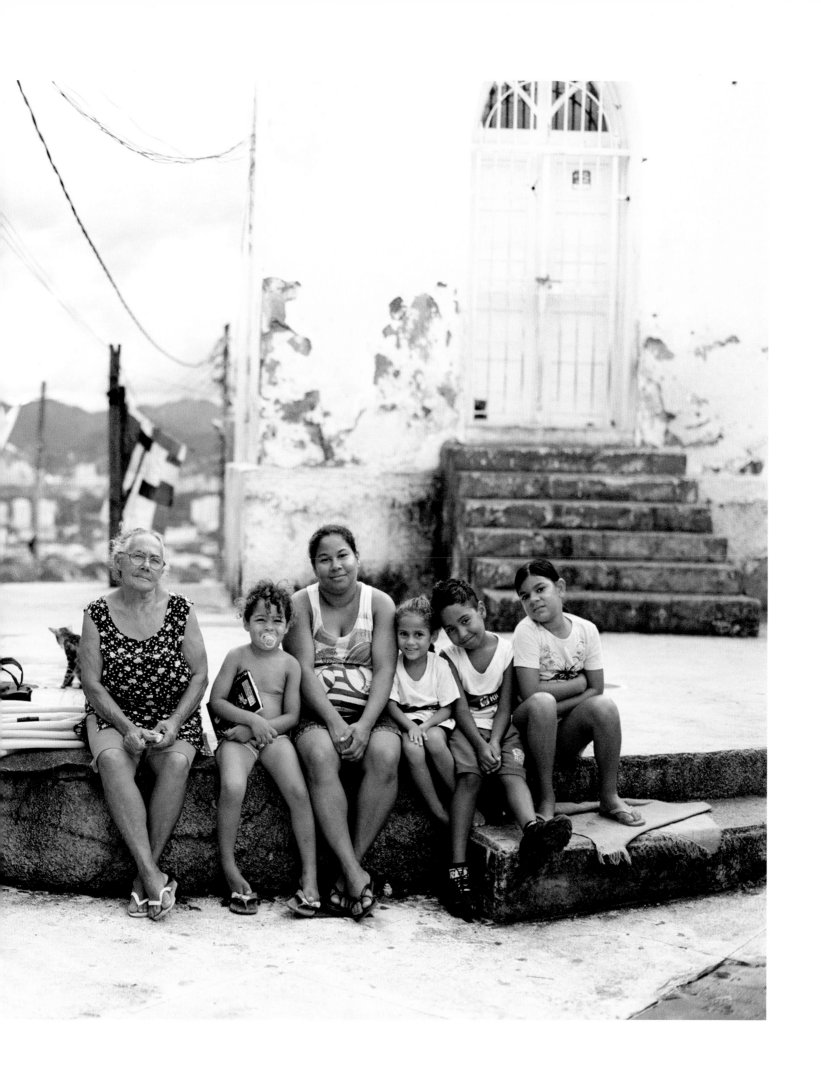

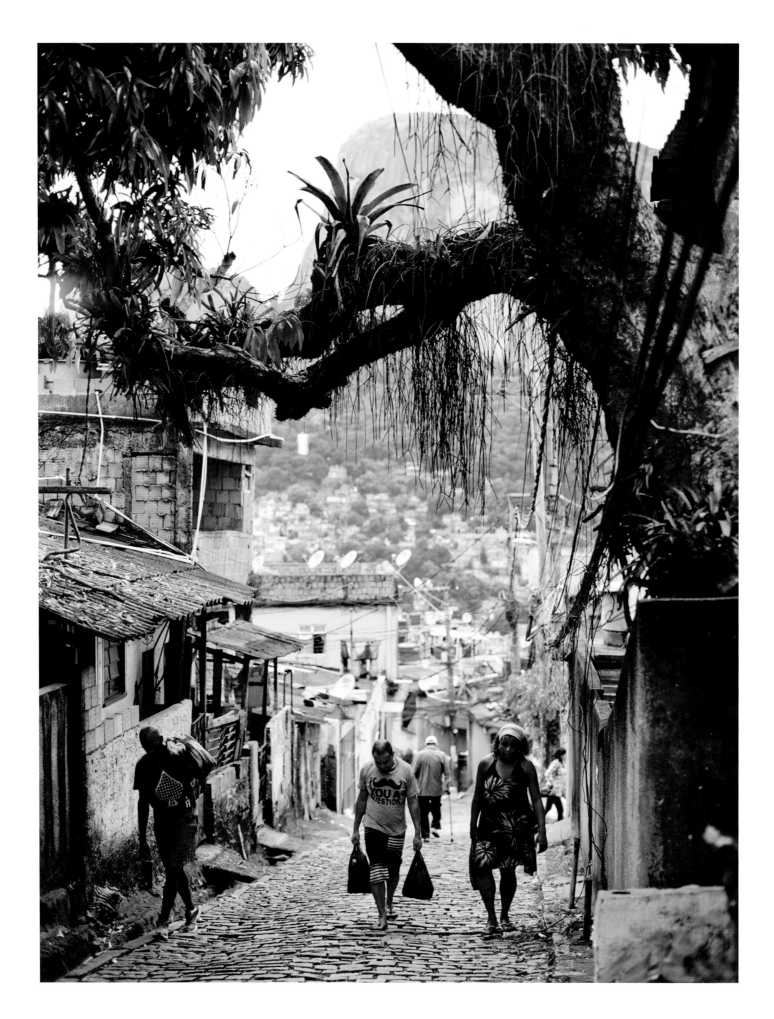

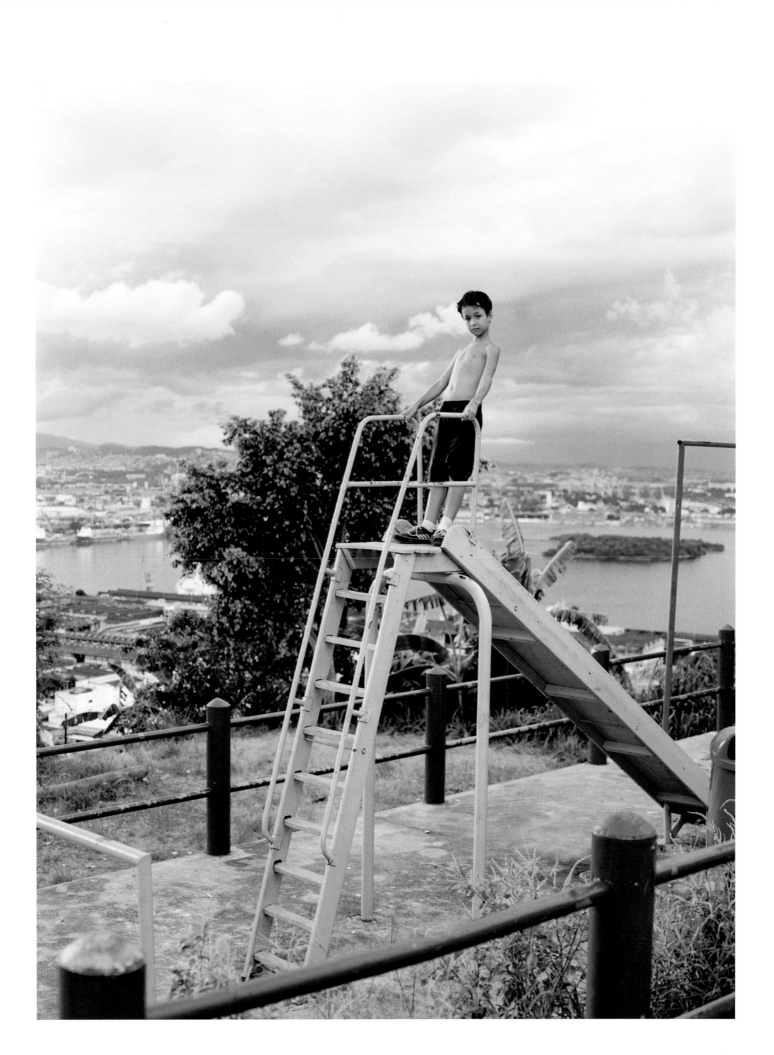

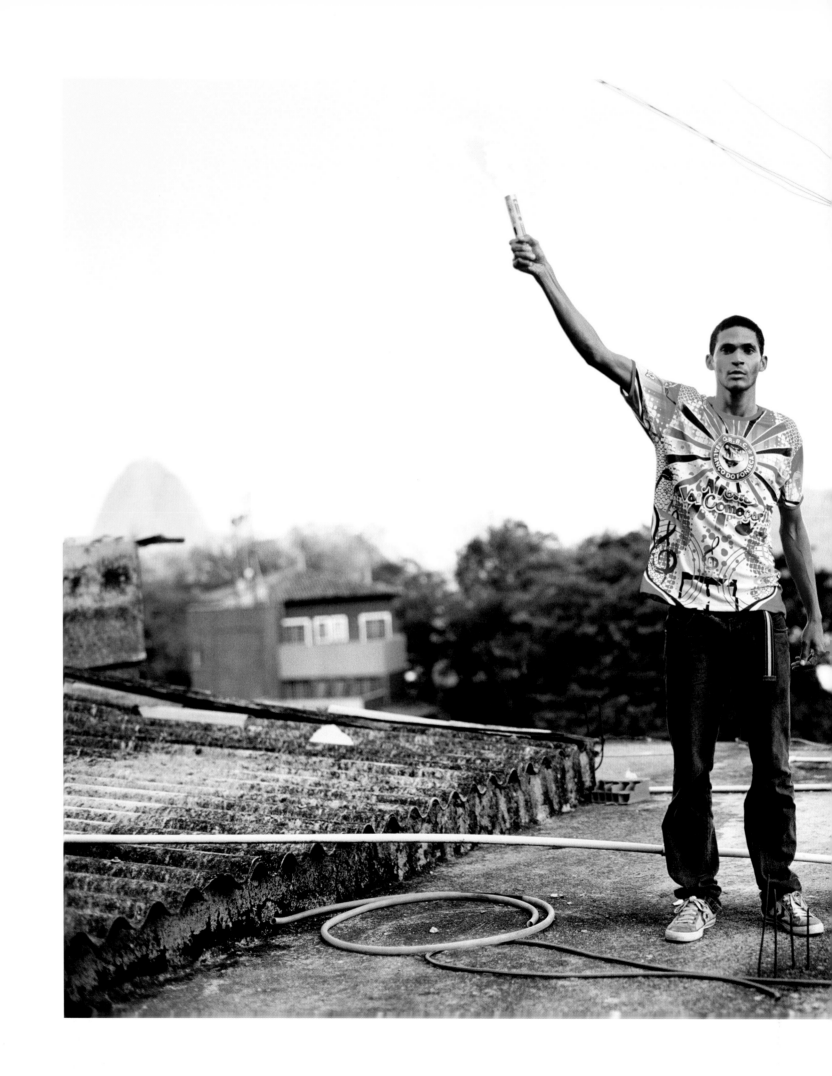

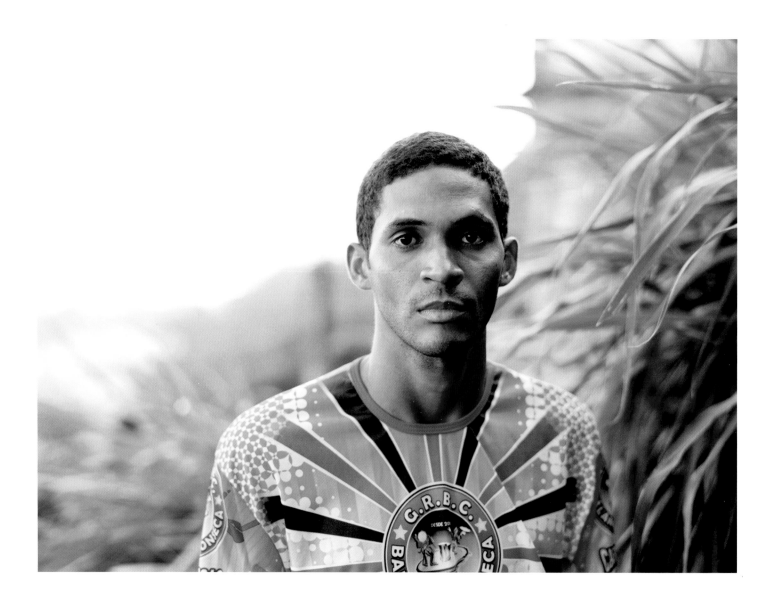

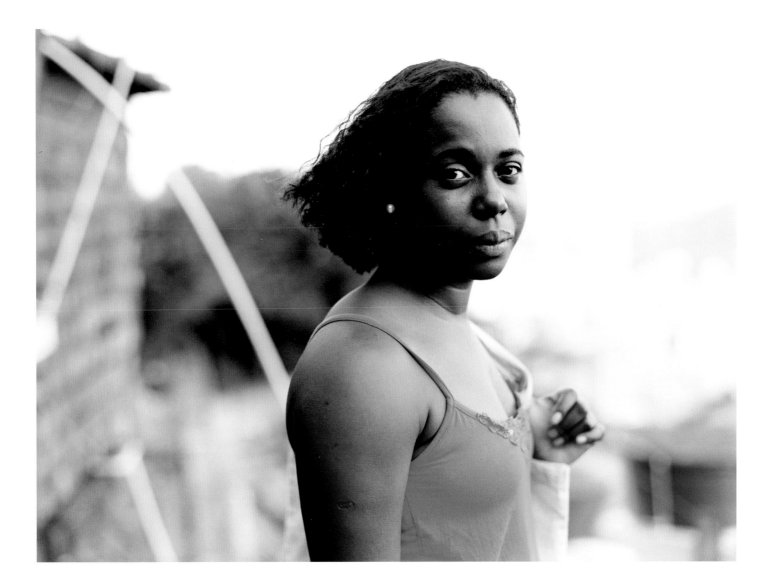

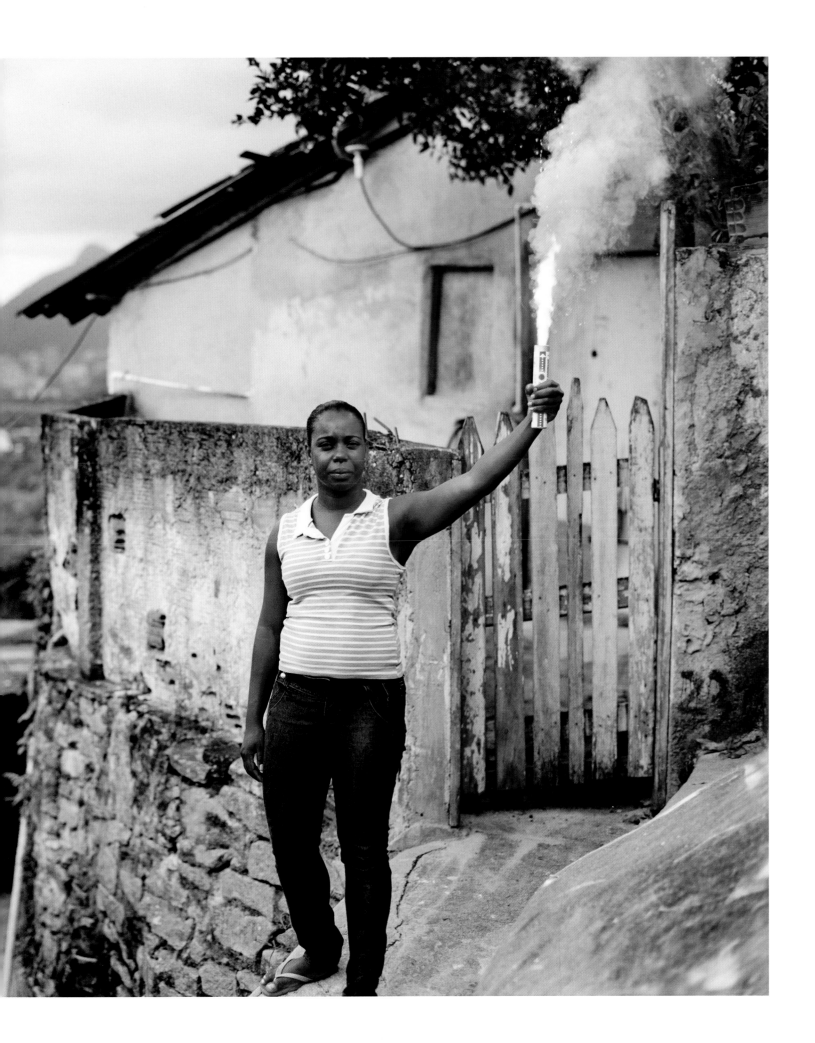

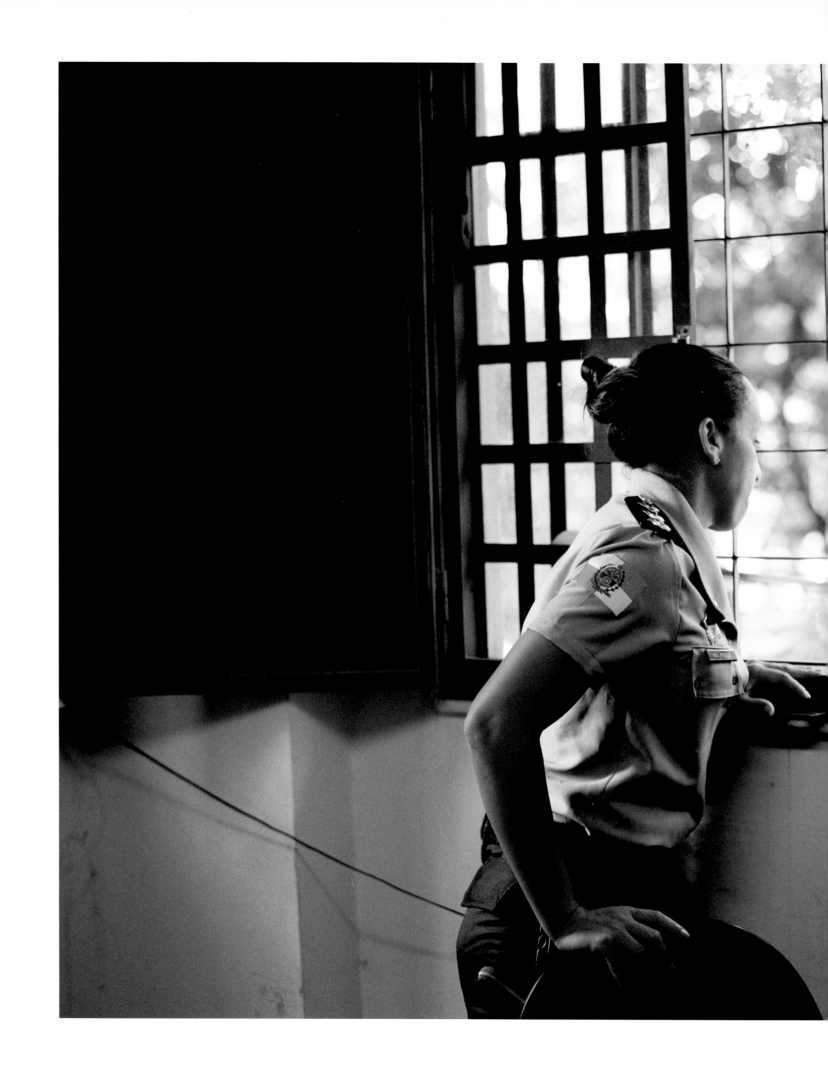

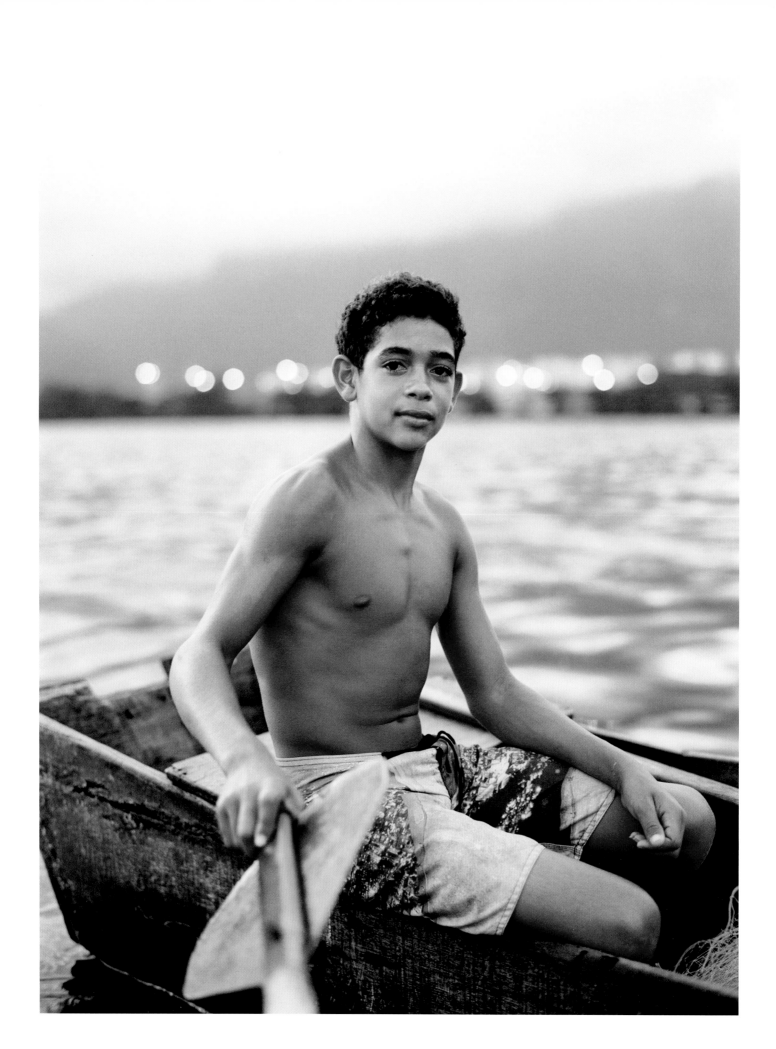

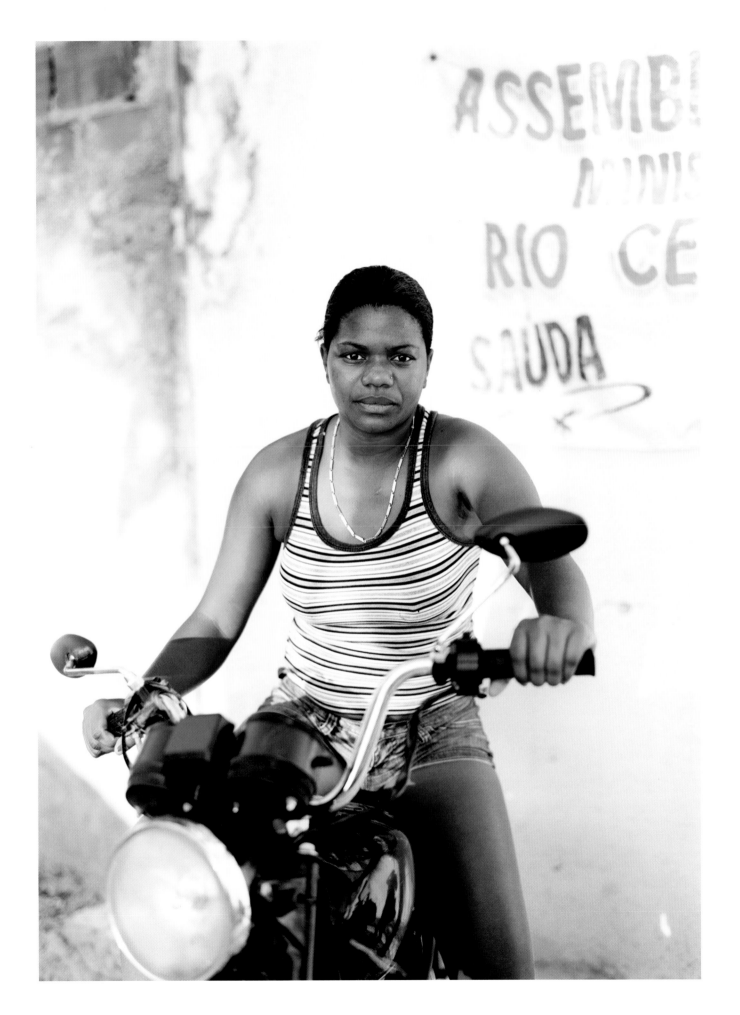

RIO IS OURS

Itamar Silva

Director of *Instituto Brasileiro de Análises Sociais e Econômicas* – Ibase.

Rio de Janeiro is a city that attracts people from all over the world for its geography, for the peculiar way its land has been occupied, and also for the diversity and joy of its people. In this context, the *favelas* are a de facto synthesis of the city's urban landscape. They are places that feature a history of struggle for rights and resistance. They are the communitarian home alternative created by the dispossessed, in the absence of a housing policy to encompass and embrace those who work and live in the city, often working in service of the city itself. In an environment where social-economic inequality persists in pushing and removing them to the city's fringes, favela dwellers make their mark, disputing their rights and claims on the city.

I was born and raised in favela Santa Marta in the Botafogo neighborhood. I continue to reside there now, and have witnessed how people in my community have recently come under the threat of arbitrary removal from their homes.

Cidade Maravilhosa, as Rio de Janeiro is affectionately called, dove headlong into the competitive logic of global cities: commoditized and completely subordinated to the rhythm and interest of speculative and real estate capital. Within this dynamic, the city's human dimension has become rhetoric to sell more artificial things.

Rio's mega-events are the justification used for any and all urban interventions—from unclogging a storm drain to displacing poor families to faraway areas. According to the *Comitê Popular da Copa e Olimpíada do Rio de Janeiro* (World Cup and Olympics civic league) thousands of residents have already been removed to accommodate these events. The most blatant example of this intention to "cleanse" the city of its visible poor is in the community of Vila Autódromo, in Rio's West Zone. Since this is the newest emerging region of business and luxury condominium expansion, collusion between the mayor's office and real estate capital has created intense pressure to "clean up" the area.

In a democratic process, mediation between unequal powers is necessary. However, in this case, the public authority that could/should assume that role is completely absorbed in the logic of city-as-business with its imperative to open spaces for more investment. "The city advances in a direction opposite to that of social integration and the preservation of human dignity."[1] It is up to civil society to get behind the various communitarian initiatives that fight-and-resist and, above all, engage in a symbolic battle for an all-inclusive city.

It is essential to defend Rio de Janeiro's diversity. After all, isn't that what makes it the *Cidade Maravilhosa*? Rio is ours: it belongs to the poor, the rich, the middle class, black, white, and all shades in-between. "Above all, the city is the result of the dreams of the people who inhabit it."[2] In his photographs, Marc has captured faces and expressions revealing the plight of human beings under the menace of removal: their resistance, indignation, fear, and hope. Their eyes shine and interrogate. His pictures draw our attention to crucial questions of our time: What kind of city do we want? Which city model will prevail?

Marc's images are warnings, alerting us to what is happening here, in this place. Men, women, and children express their *alegria* to live here, their commitment to defend their homes here, and their resistance to the threat that hangs over them. Life pulses and reproduces despite the mercantile vultures that treat everything and everyone as commodities.

This grouping of sensitive photographs reveals the emotions endured by a sizable population in Rio de Janeiro under the omnipresent threat of removal. And they seem to propose "a culture of communitarian activism," a contagious notion that could stimulate resistance in favor of a democratic and diverse Rio, mobilizing even those in more comfortable situations who might not feel similarly threatened. I join forces with those who support a city distinguished by its capacity to hear, respect, and accurately portray the desires and choices of all its inhabitants.

1 Dossier: "Megaevents and Human Rights Violations in Rio de Janeiro."
2 Article: de Mello, Paulo Thiago. "A cidade em processo de transformação." O Globo [Rio de Janeiro] n.d., "Cidade em Transe" n. pag. Print.

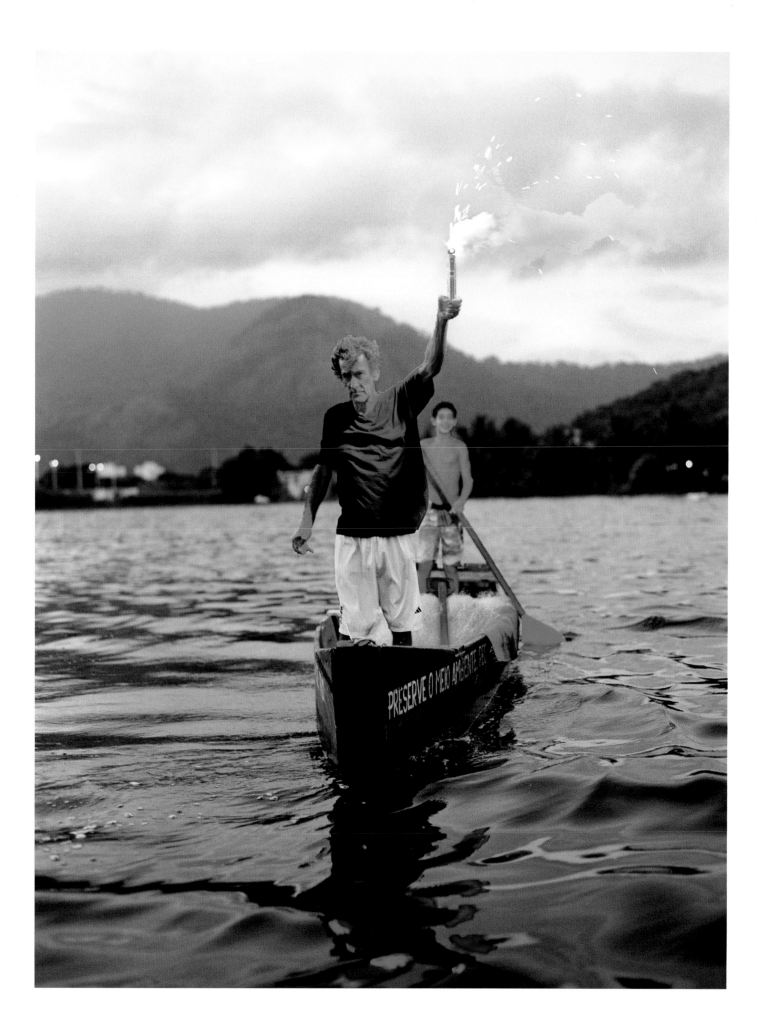

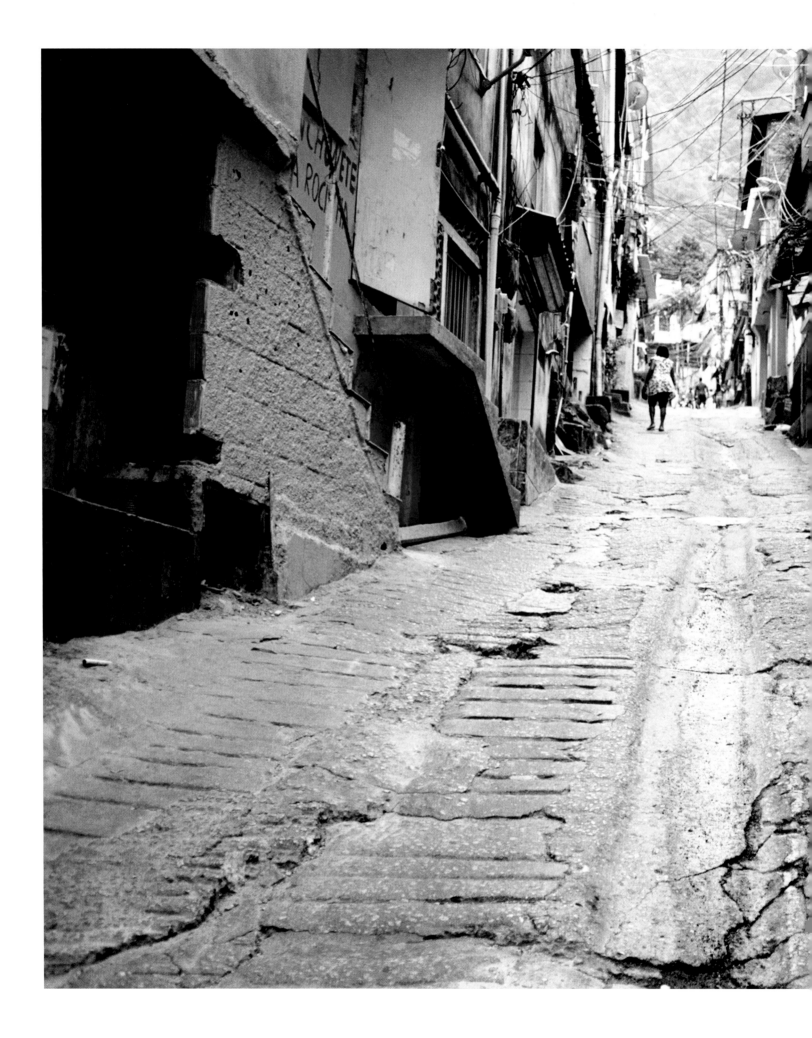

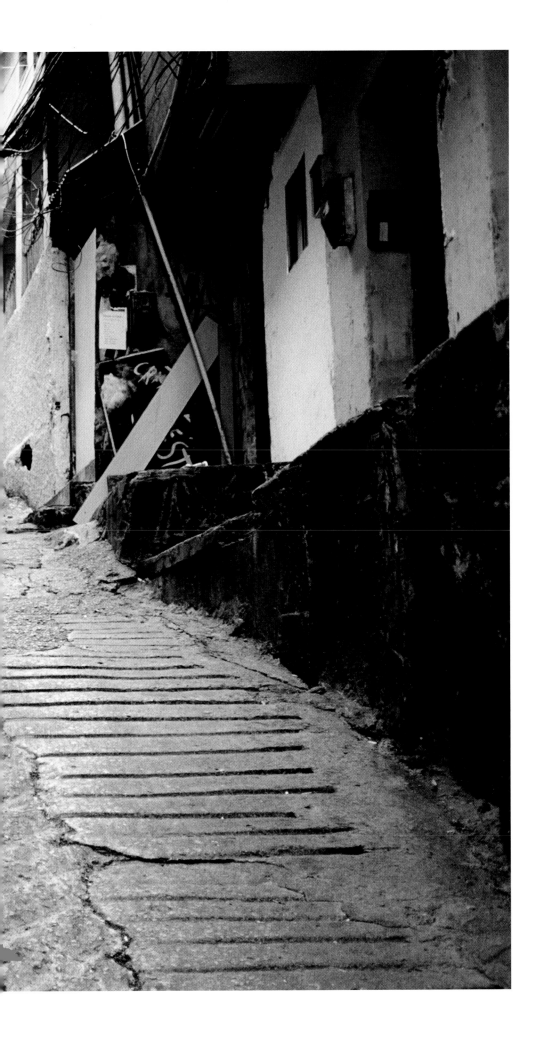

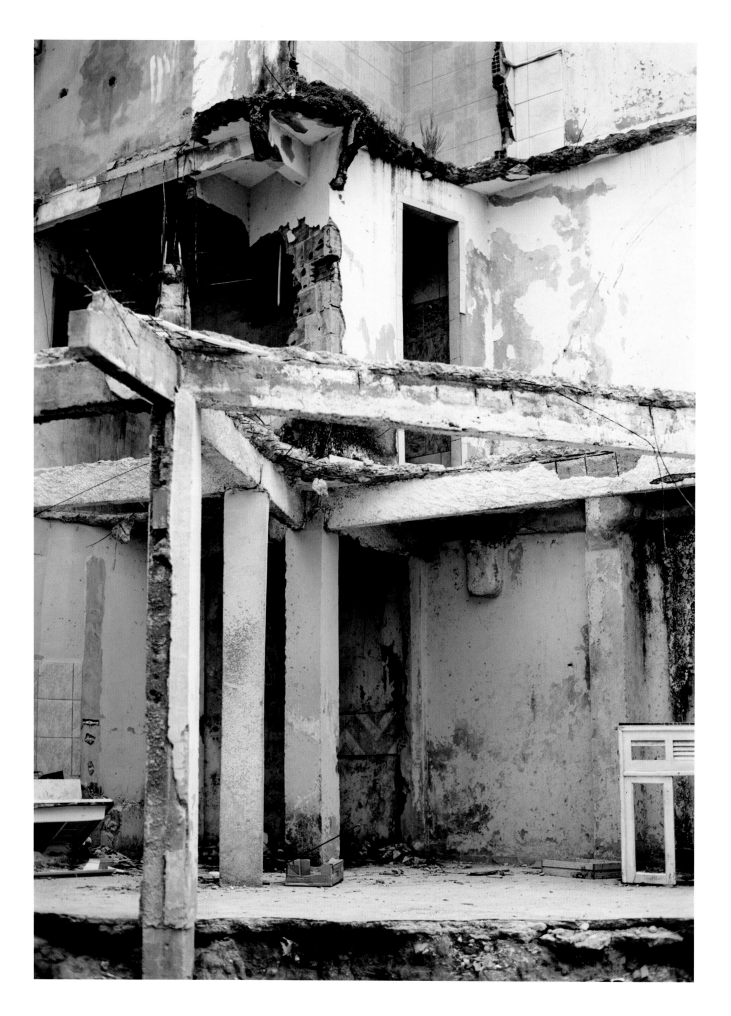

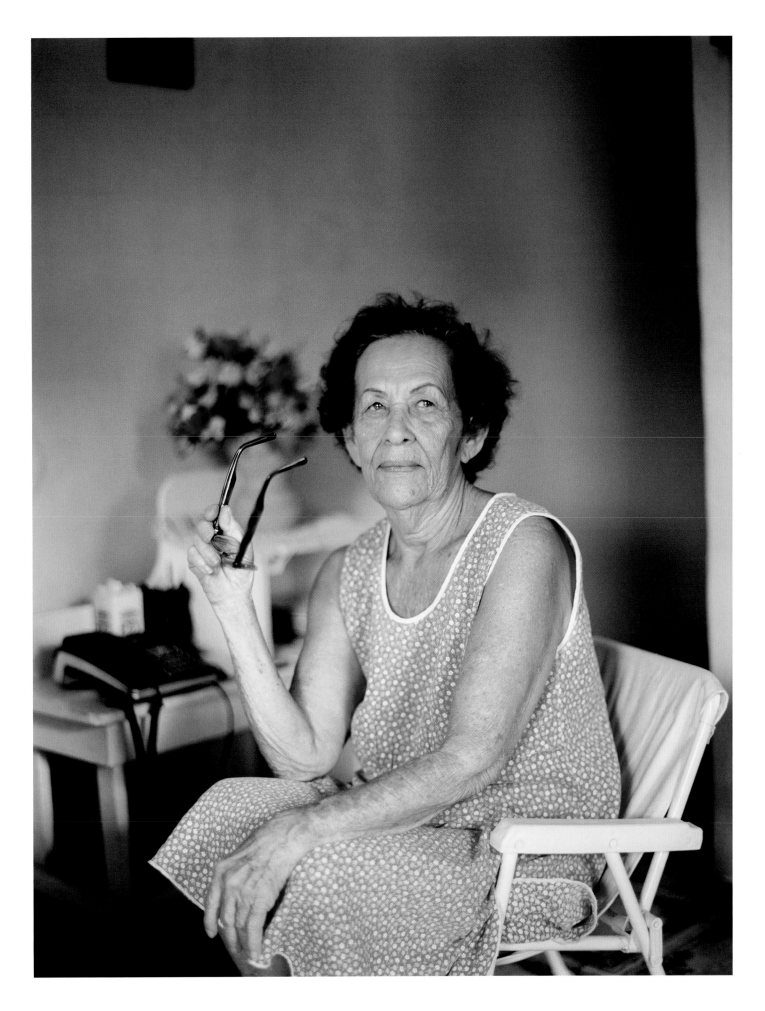

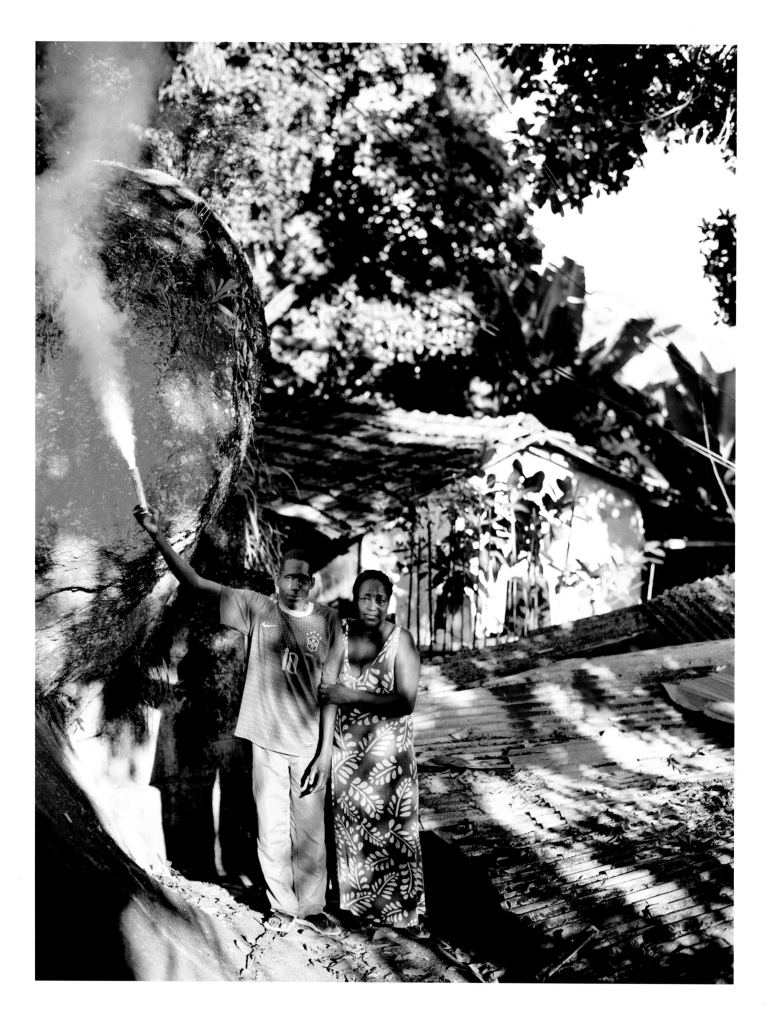

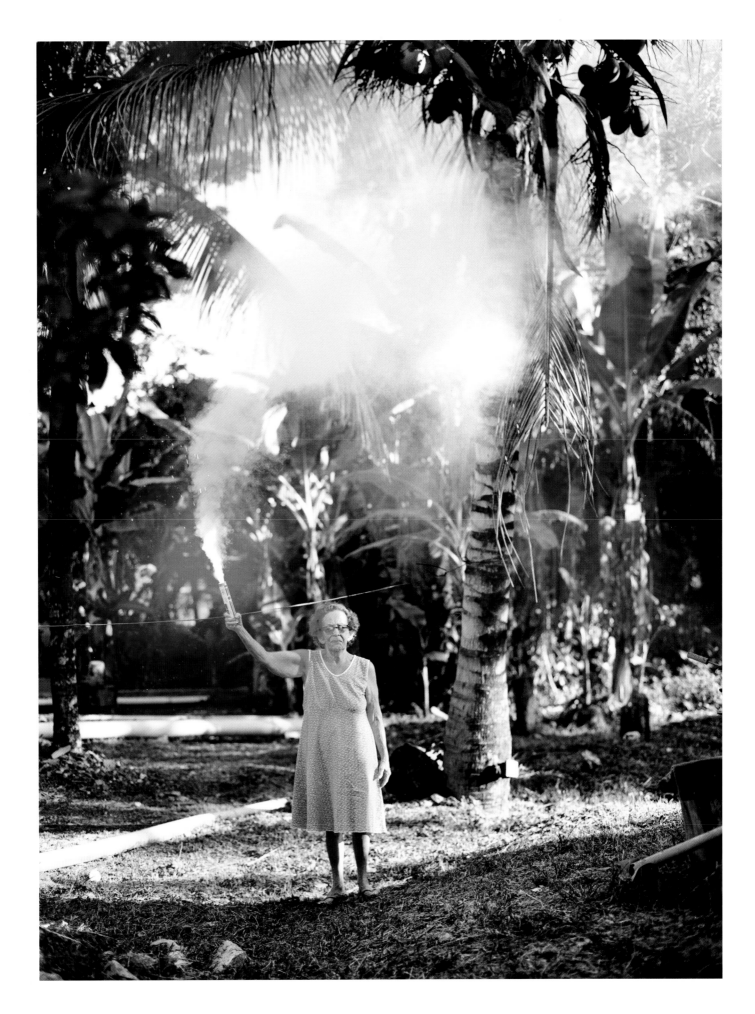

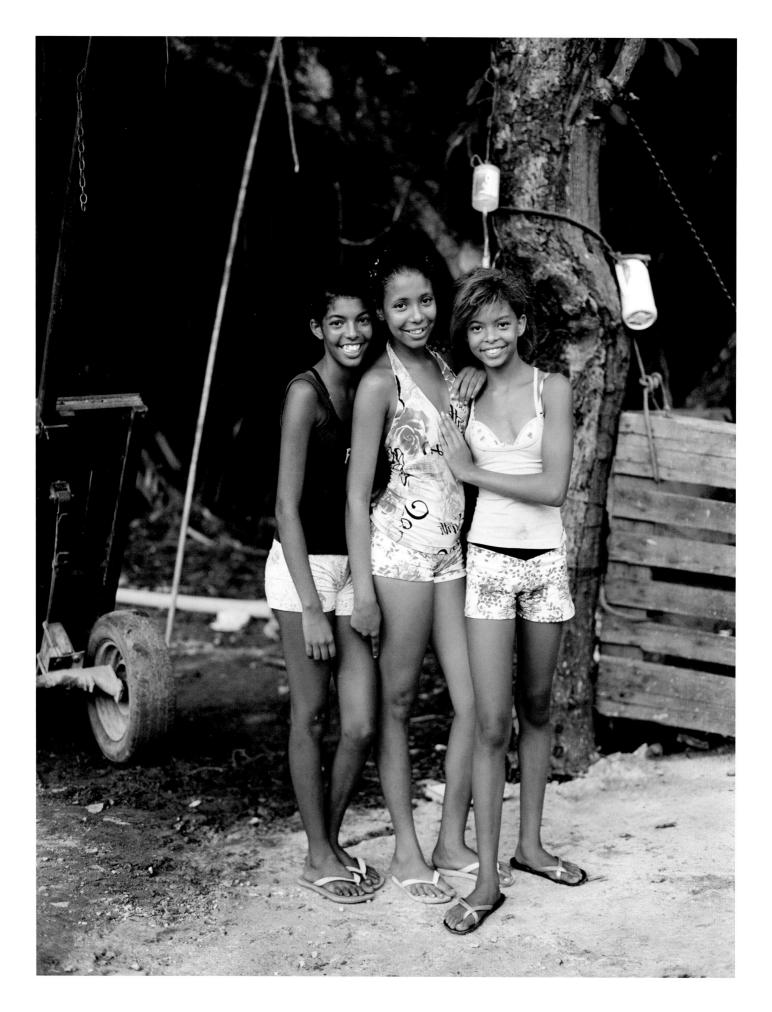

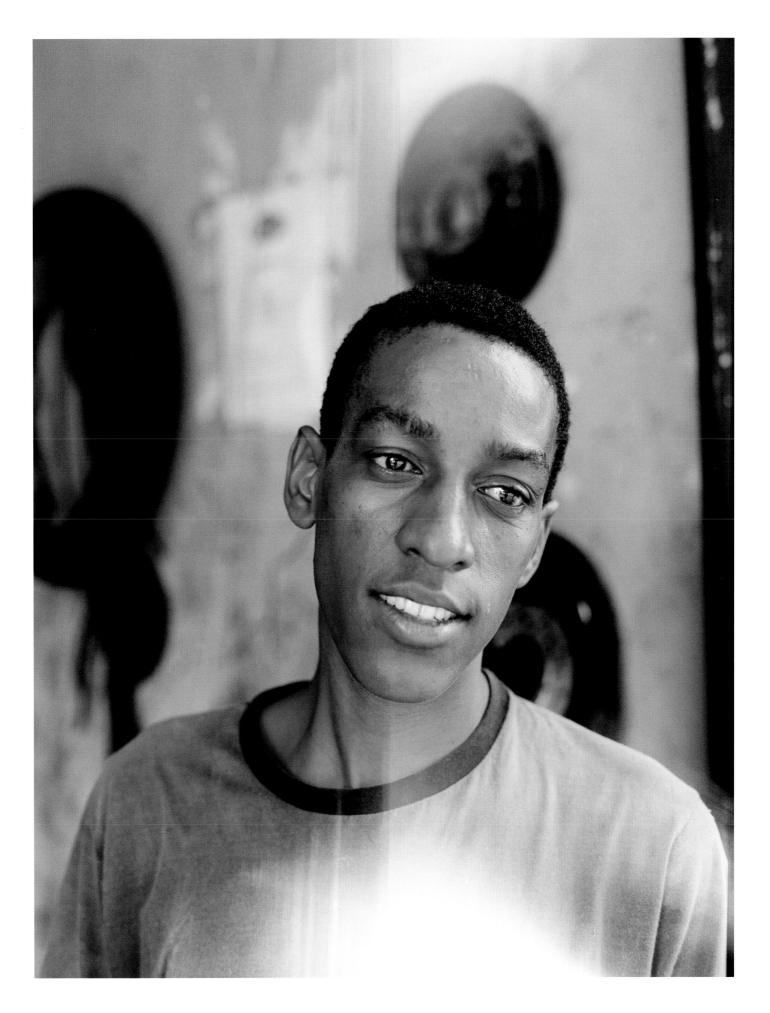

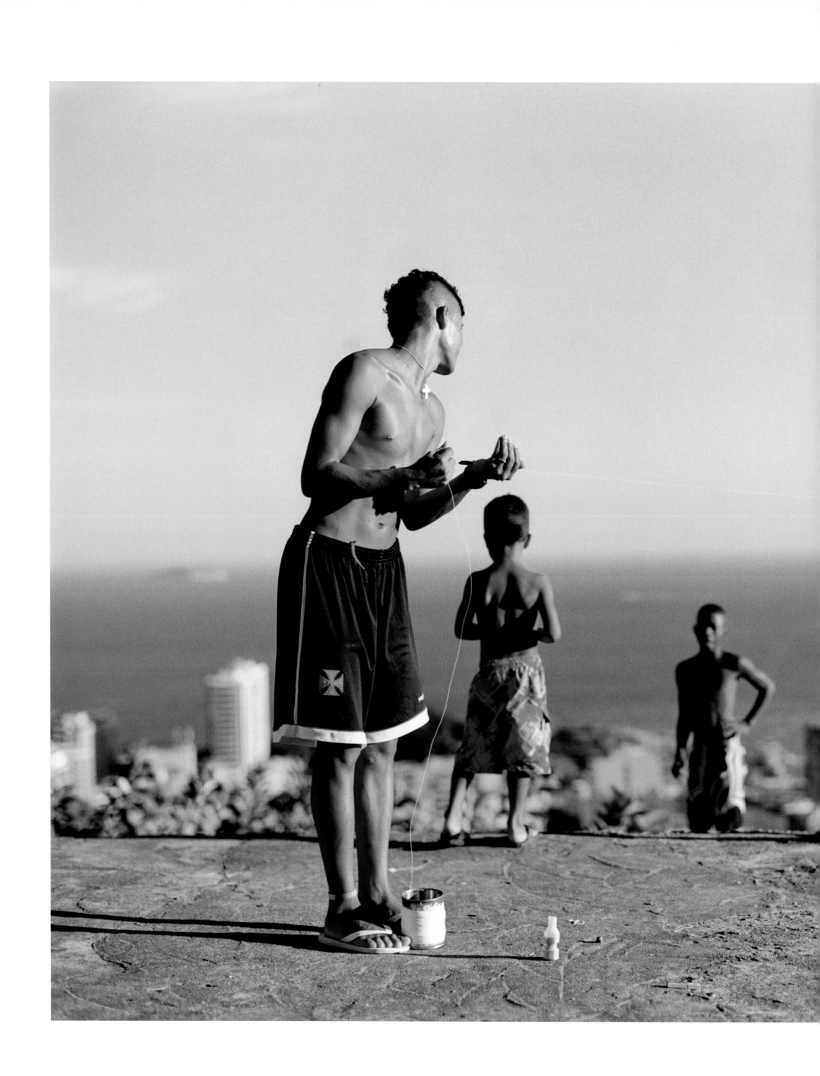

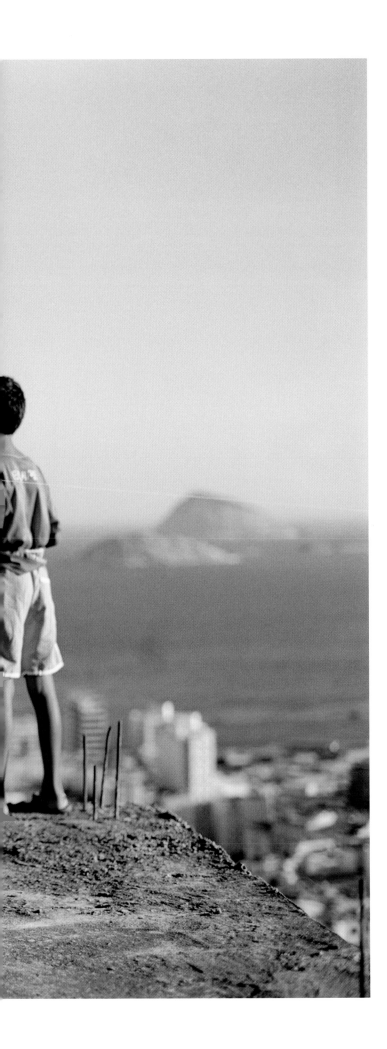

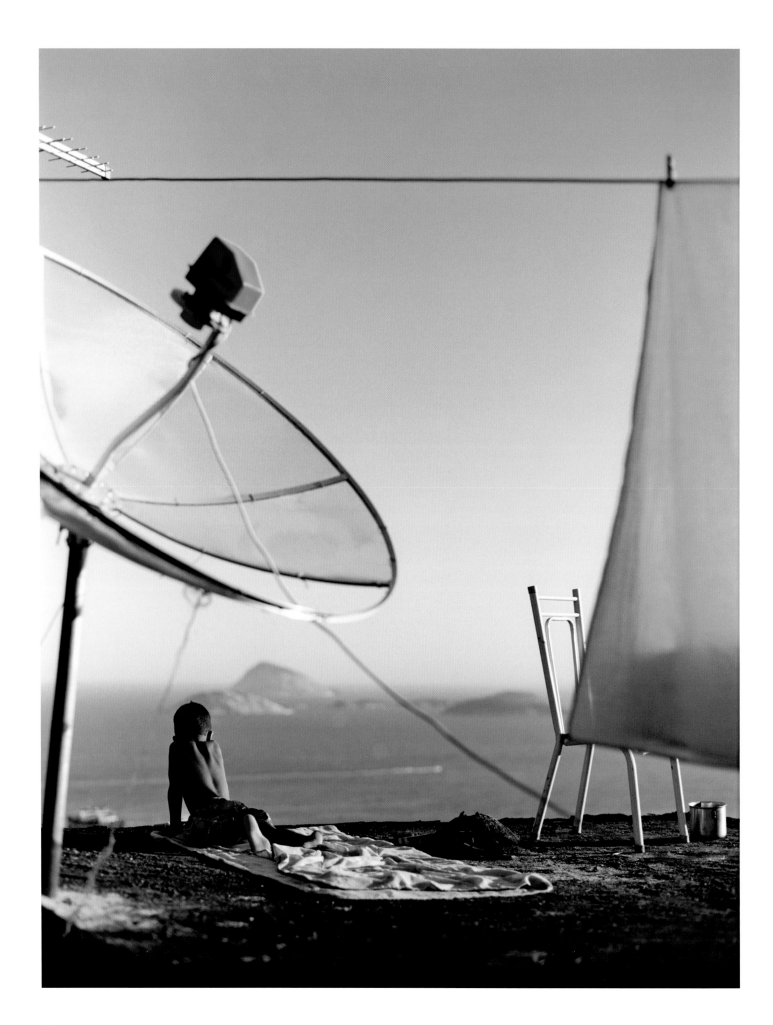

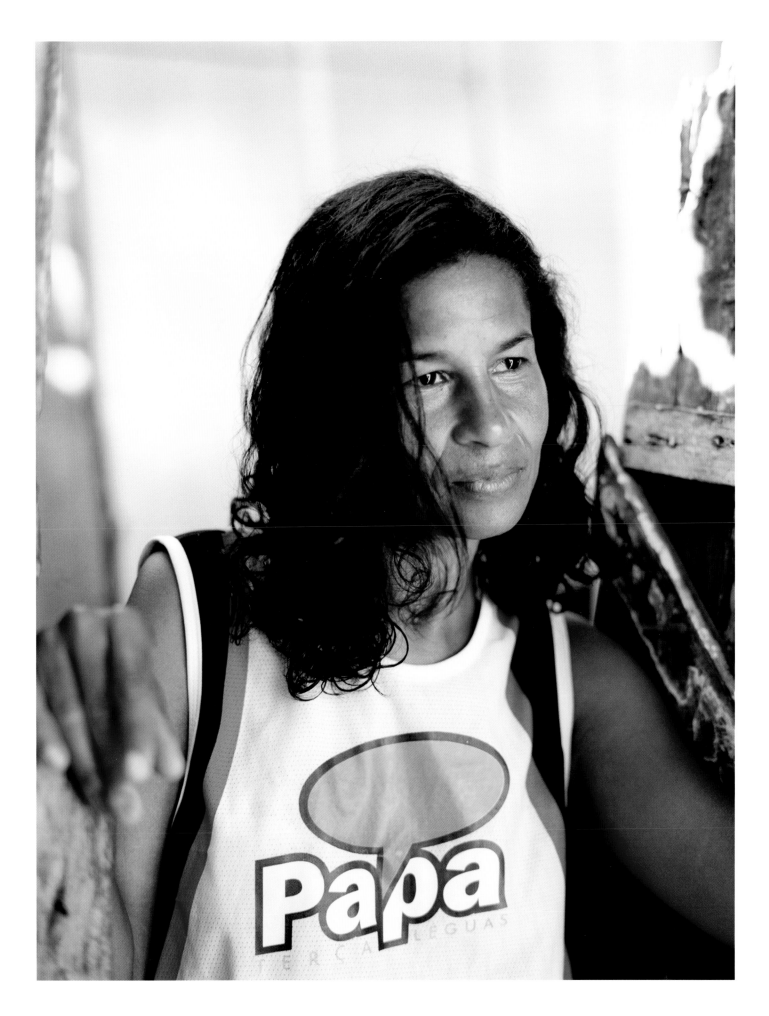

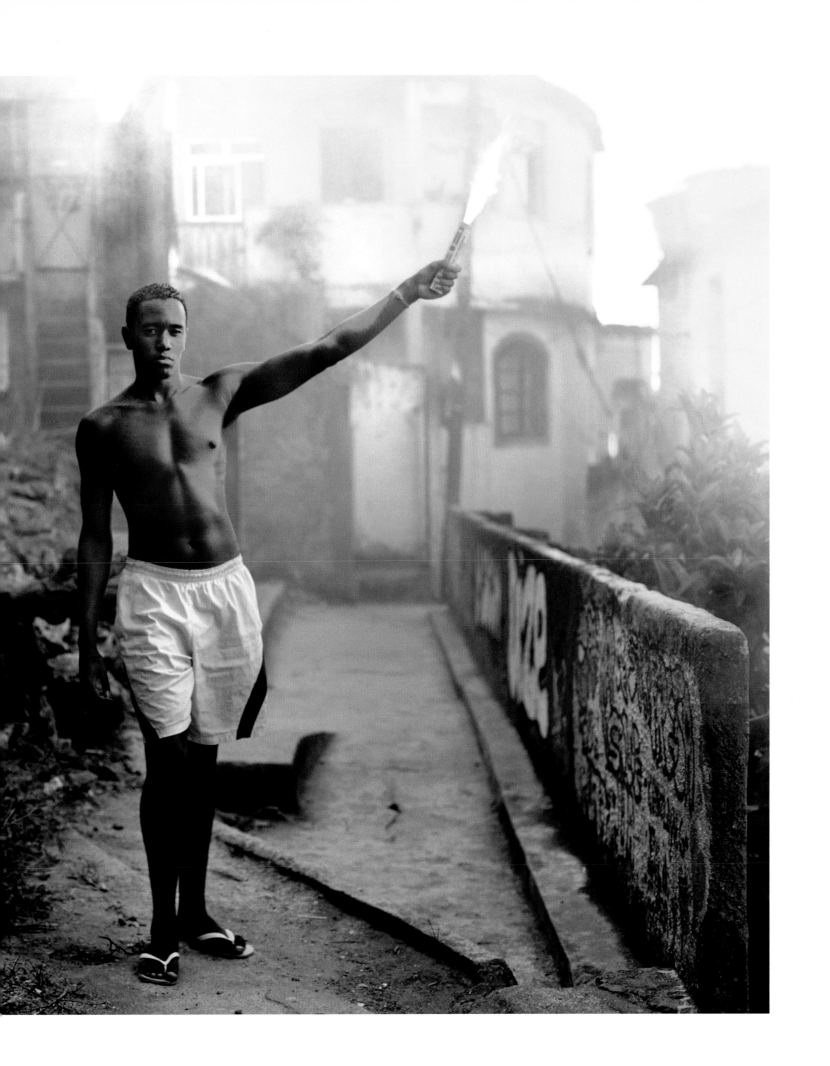

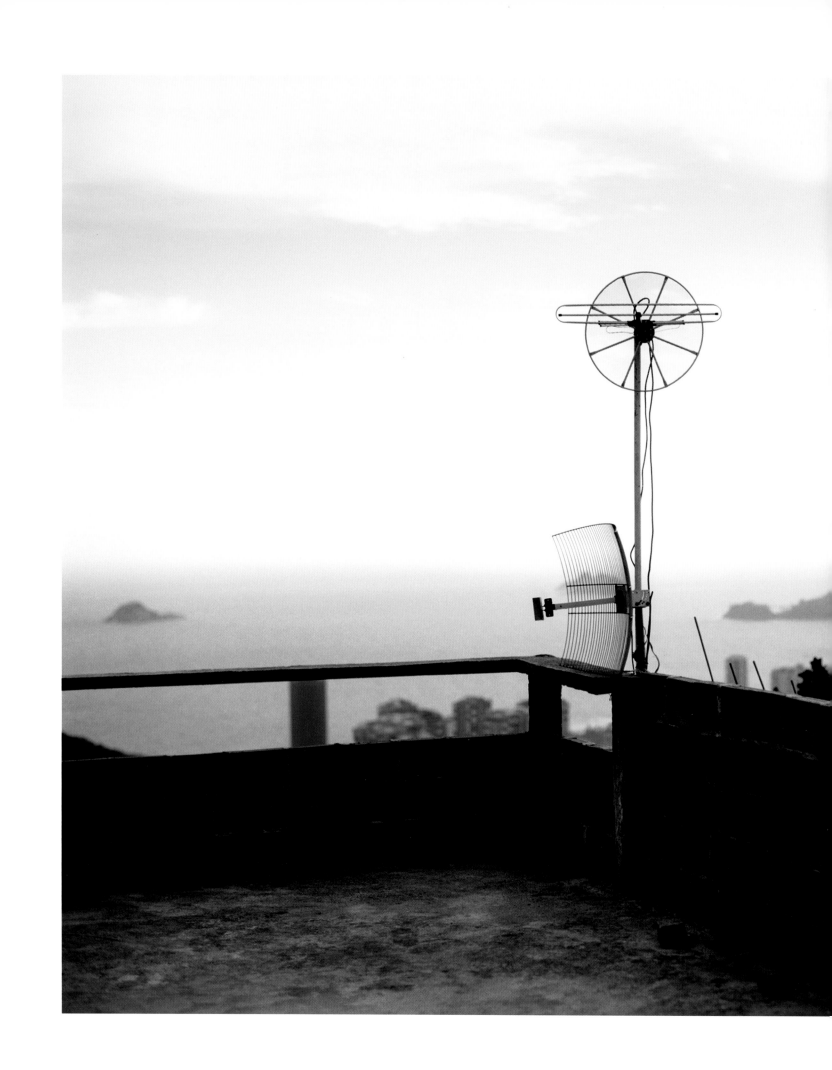

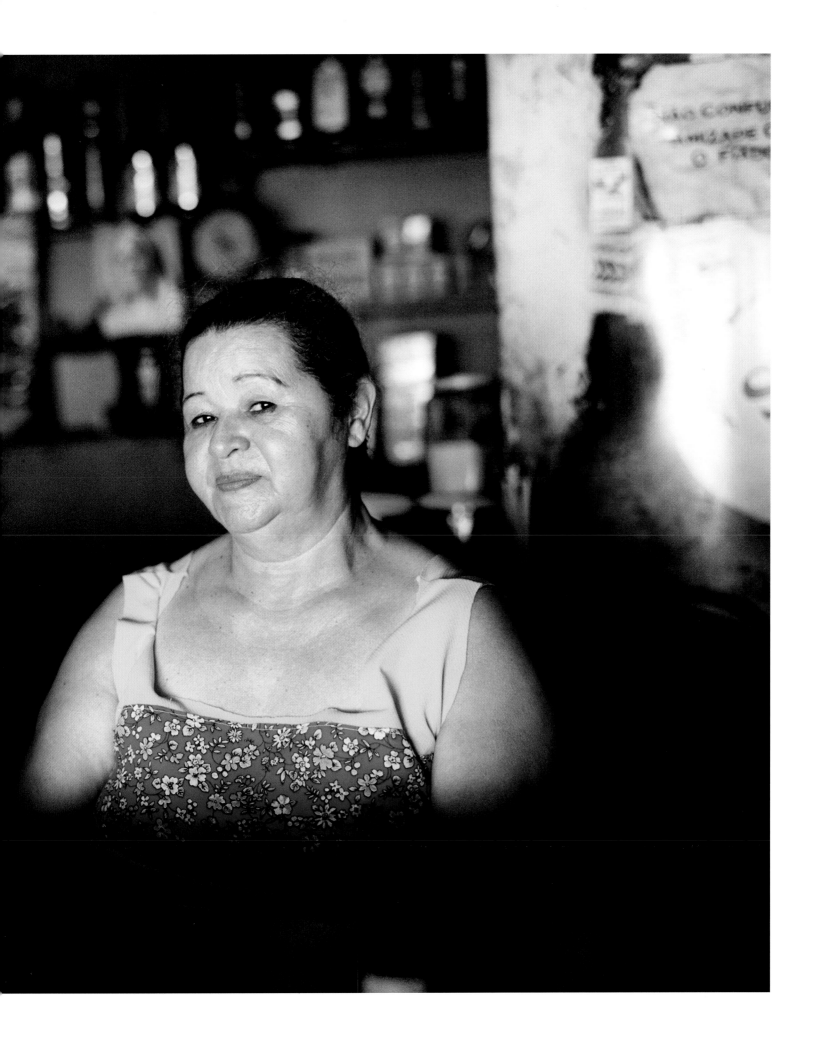

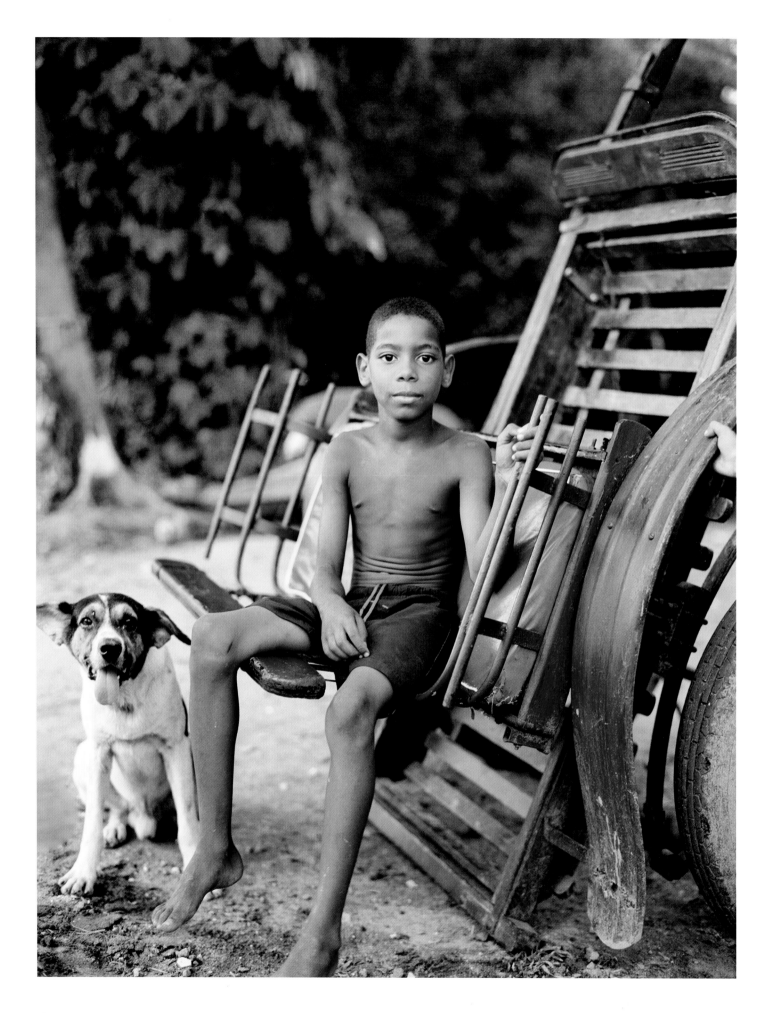

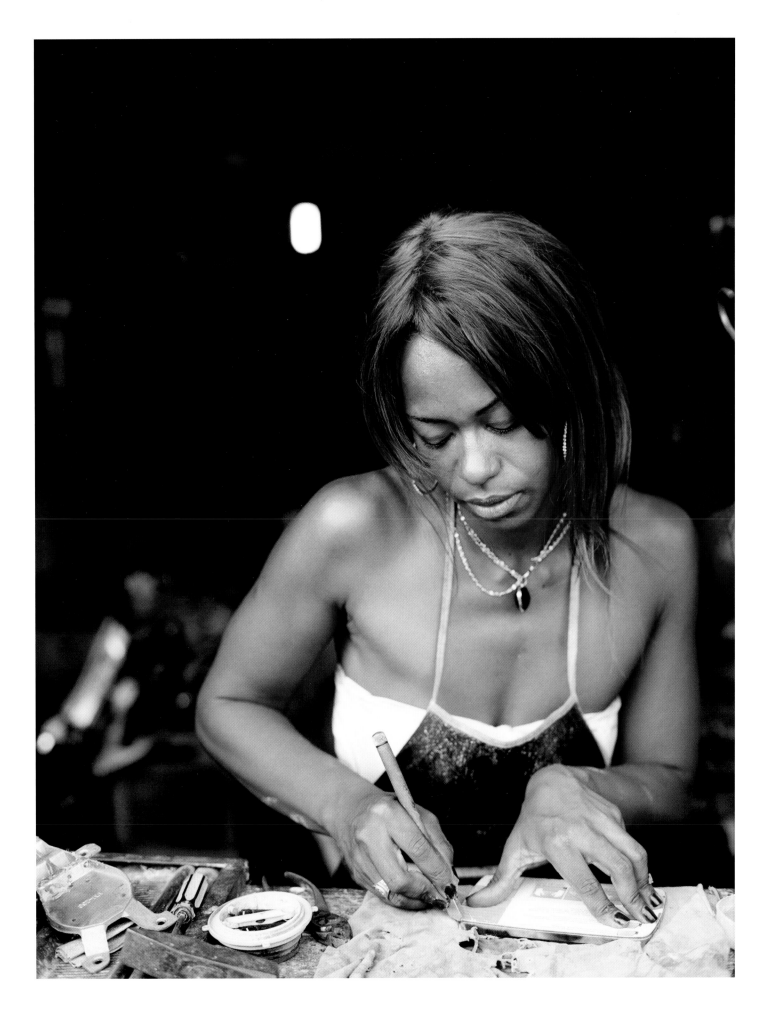

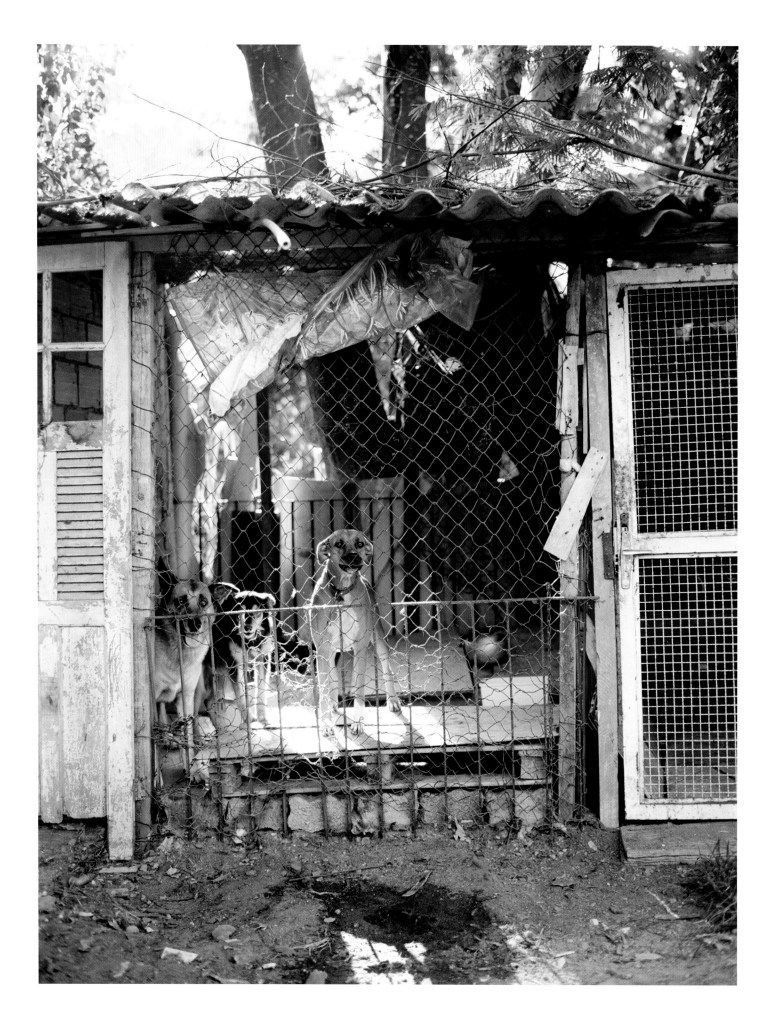

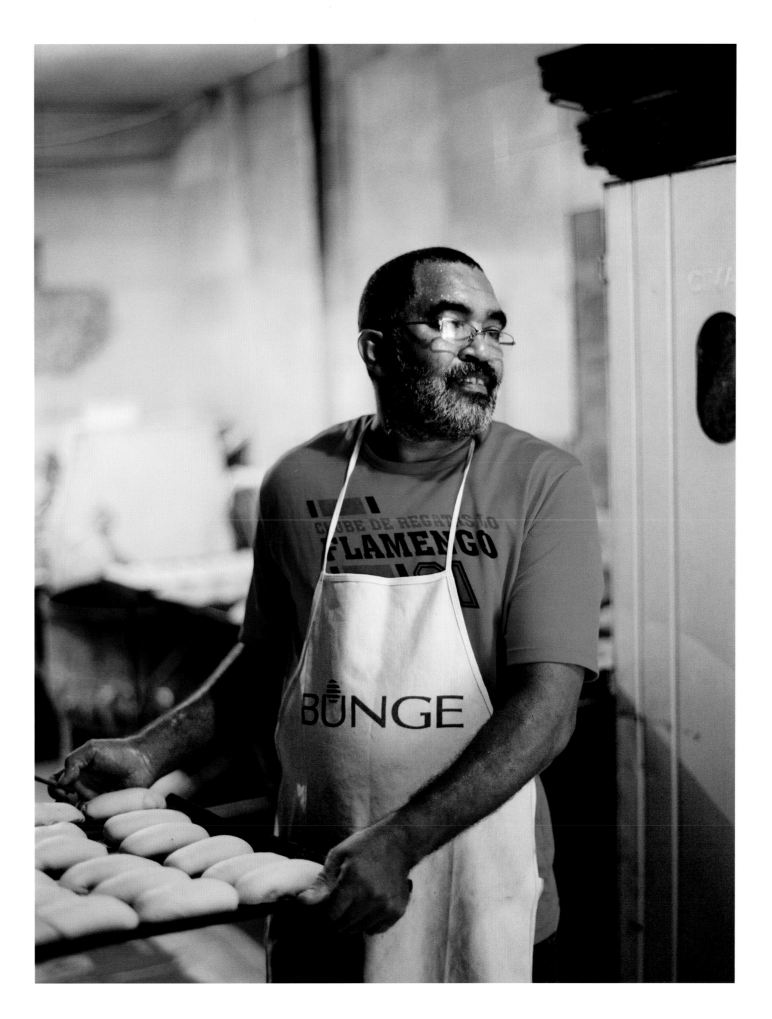

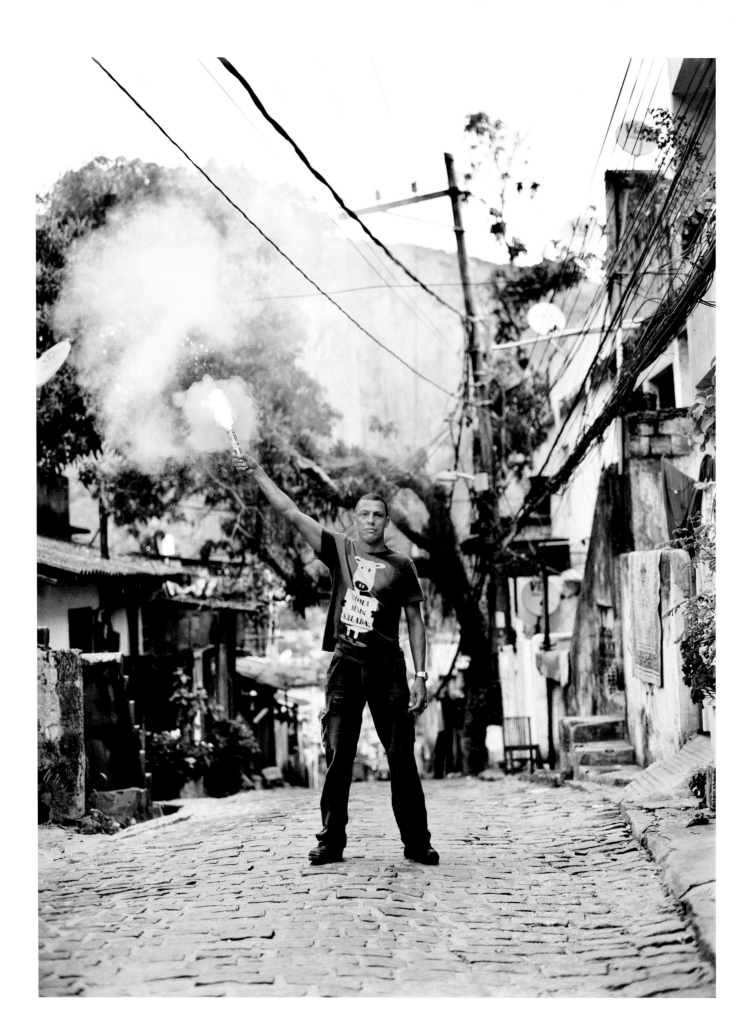

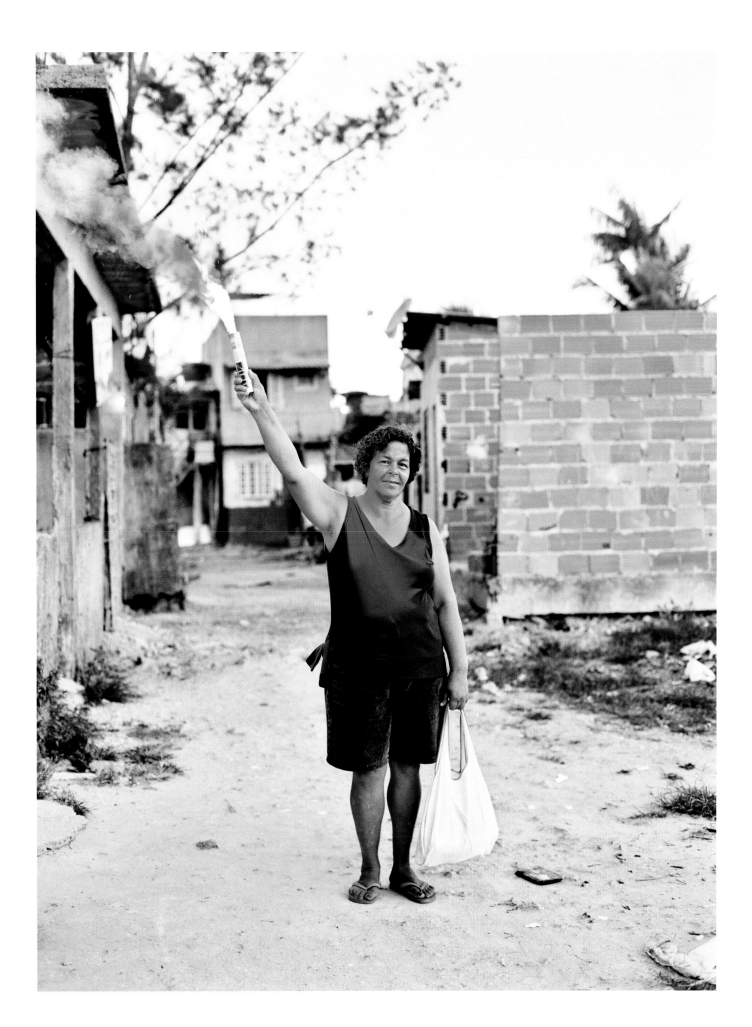

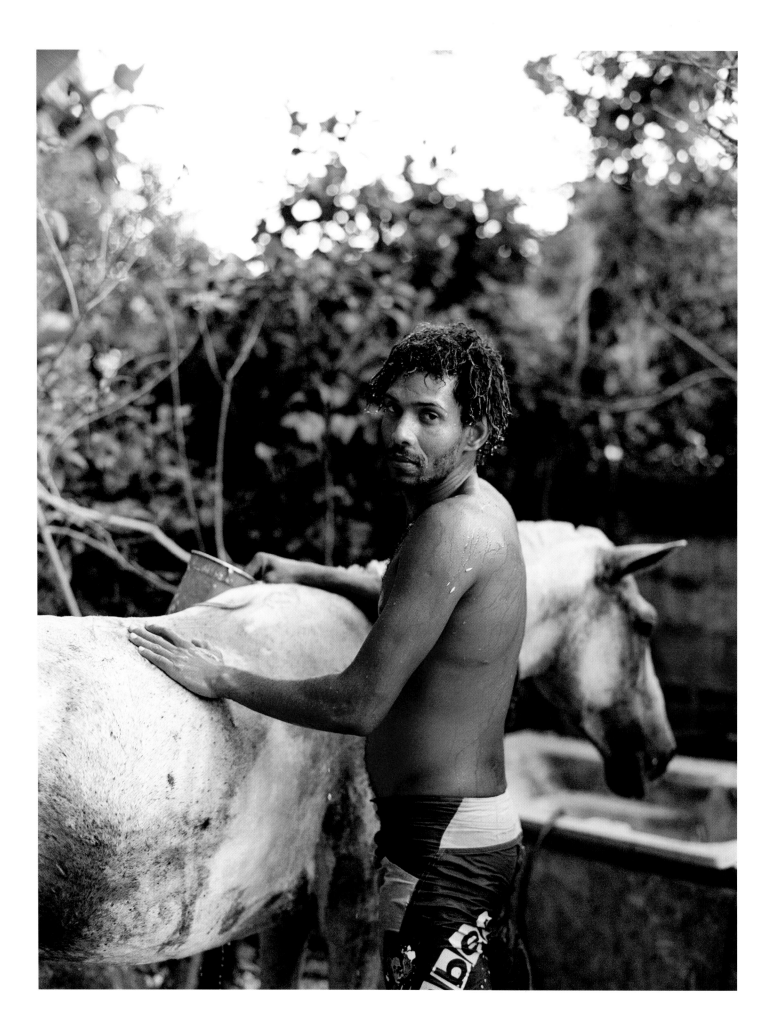

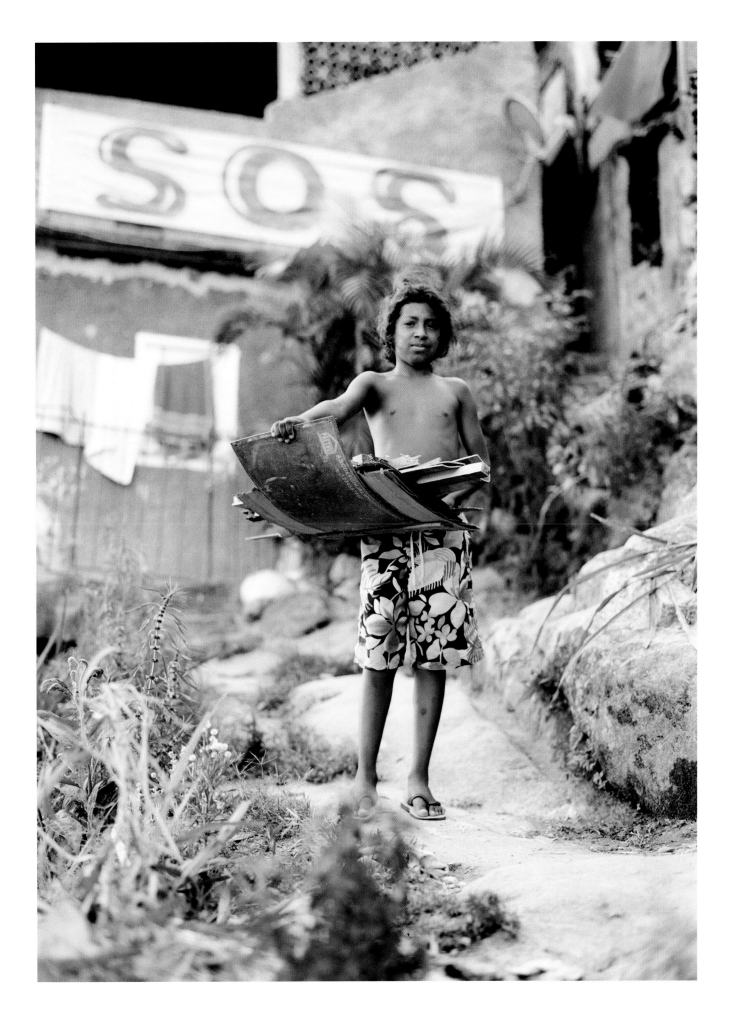

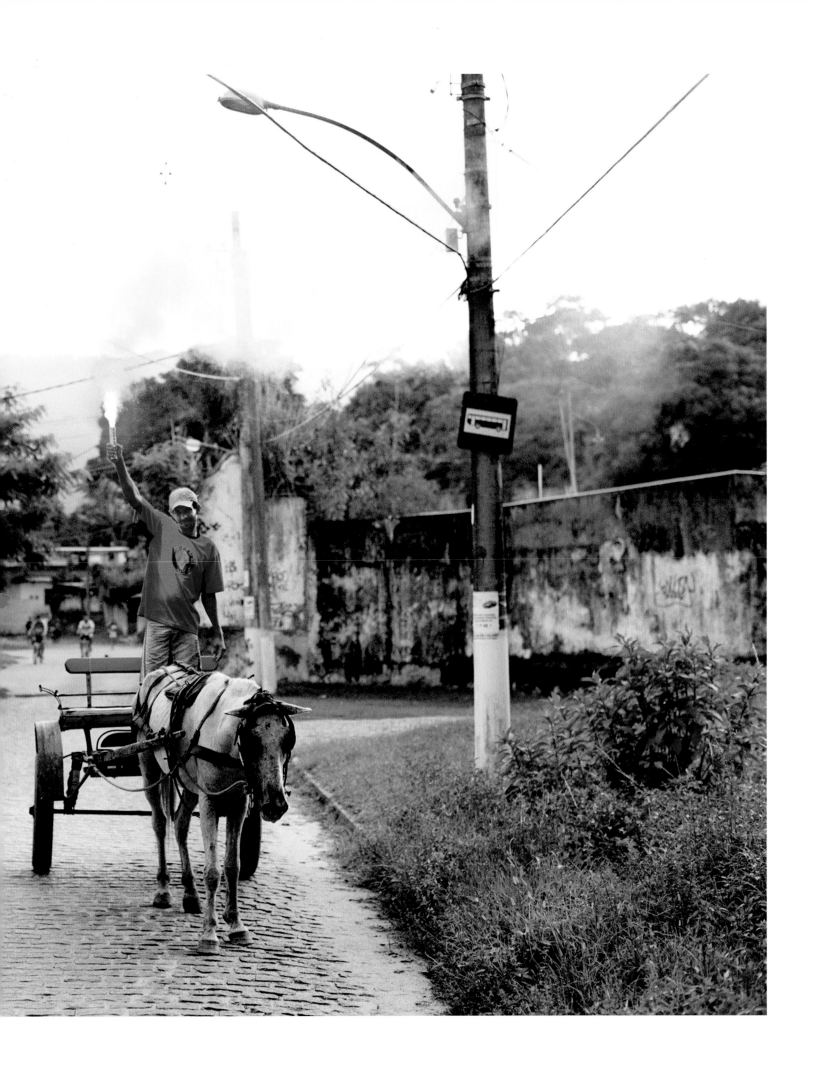

BRAZIL: *NONE-PLACE WITH A BURNING NAME*[1]

Luis Pérez-Oramas

Over the past two years, I've lived in Brazil longer than anywhere else. I was charged with the difficult and joyful task of organizing the Sao Paulo Biennial, the oldest art biennial other than Venice, and the most significant artistic event in the nation. To do this work, I had to travel throughout the country: I made many new friends, I worked closely with people from all social strata, I met students from the interior of the country, public schoolteachers, social activists, militant homosexuals, religious authorities. I visited with poets, intellectuals, artists, gallerists, academics, civil servants, publishers, journalists. I was charged with working with public and private institutions—for example, with the remarkable SESC (Trade Social Service), which offers cultural, sports, and health-related services to the urban and rural working class and to industrial and trade employees. I met some members of the new elite classes, unimaginably wealthy young people who, for a variety of reasons, had placed themselves at the forefront of educational and public interest initiatives like the Sao Paulo Biennial. I wrote for the press; I presented myself at government offices in defense and promotion of the Biennial; I met with high-level State officials and with university authorities. I lived in Sao Paulo for eight months continuously, using public transit, making a life for myself in my neighborhood; I traveled for pleasure and for work by car and by plane; I experienced one of the most fascinating and expensive cities on the planet. I can say that I could (and I would) go back there in an instant. I read Brazilian literature and history constantly; my favorite poets, today, are Carlos Drummond de Andrade, Murilo Mendes, Joao Cabral de Melo Neto; I listen incessantly to Caetano, whom I also read, in his clear, inspired, and keen prose; my life is given rhythm by the images and the voice of Chico Buarque and nothing makes me feel as deeply myself so much as Nana Caymi's unparalleled timbre or the husky soul that resounds in the voices of women like Bethania or Elis Regina.

Throughout this time, my experience has alternated between two certainties. First, that Brazil has come to be the country I would wish for my country, Venezuela, one day to become; or to say this in a more general way, that Brazil has come to embody—at least, seen from the epidermis of its social life, and to the extent a foreign visitor can perceive its reality—something like a desired social model: an open and tolerant society, wholly dedicated to its modernity. The second certainty, in contrast to the first, is that Brazilian society is based on enormous contradictions, and hardly the least of these is the fact that Brazil is the only nation on the American continent where public policies are directed, simultaneously and with equal intensity, toward satisfying necessities for economic growth and freedom—with the vast residue of injustice these imply—and toward correcting age-old, dramatic contrasts in access to wealth and to social well-being, with the well-known and reviled "Brazil Cost." At the same time, as it happens, Brazil is the country where one single state—Sao Paulo—would, if it existed as an independent nation, be among the most economically powerful on the planet; it is also the country where a vast immensity of uncultivated, forested, and desert lands in the northeast continues to be the homeland of millions of people who have been forgotten by programs of social well-being, and live in the same misery as ever, and where the megalopolises of Rio de Janeiro and Sao Paulo are also similarly forgotten, due to the unimaginable dimensions of the poverty that inhabits those cities.

For eight months, every time I went to the market, I wondered what the secret is, how everyday Brazilians survive. I saw my friends working night and day, in all kinds of trades and professions, but I also saw them leading stable and desirable lives, enjoying a quality of life that's rare to see in other cities on the Latin American continent. Here are some details that perhaps are not, despite their banality, insignificant; never, in two years, did I see a plane, bus or train leave behind schedule; there was never even the slightest conflict with any service provider; coming from Caracas—and even from New York—I was always impressed by the cleanliness and the high quality of certain public services. But there was also news of violence, and I never ceased to be amazed, and even scandalized, by the extravagant Saudi-style wealth that can be seen on some of Sao Paulo's streets, in its malls, in its entertainment venues. I was also continually amazed by the openness of this society, its level of tolerance, the feeling of being able to be any kind of person openly, and was amazed by the maturity and quality of social interactions, and by the certainty that I was in the only country in the Americas that has, along with the United States, successfully created a popular urban culture that goes beyond the vernacular and folkloric. Each time I heard mention of the ridiculous "BRICs" countries it occurred to me to think that unlike India or China, in Brazil the whole society speaks one single language, enjoys absolute freedom of belief, does not have to endure nationalist demands nor the risk of secession, and enjoys a healthy social democracy, within a clear system of civic freedoms.

It is also true that whenever I heard the thinly disguised pride with which some Brazilians claim already to be part of the "first world," for whatever reason my mind turned to the dramatic image of *crackolandia*, the devastated center of Sao Paulo, riddled with people without shelter, with tribal groups dedicated to the use of hard drugs, with misery and abandonment; and consequently I'd feel certain that well before Brazil might arrive at the gates of the so-called "first world," something would have to break, perhaps violently.

The tremendous protests that took place in Brazil during 2013, initiated under the pretext of a slight increase in the cost of public transit, are the clearest proof that behind the idyllic image of Brazilian society still lurk tremendous conflicts. And nonetheless, anyone might think that there are many more reasons to protest, even violently, in Caracas or Maracaibo, in Mexico, Quito or Asunción than in Sao Paulo or Belo Horizonte.

1 Caetano Veloso. *Verdade tropical*. Sao Paulo: Companhia das Letras, 2008, p.14.

This blossoming of protest has much to do with a weariness woven into the social fabric, the reasons for which few people—if any—are yet capable of identifying clearly. The symptoms of this fatigue, this exasperation, are obvious to anyone in Brazil, but they are also unobtrusive. A strong fiscal argument nourishes them: in the laborious and improbable process of formalizing the Brazilian economy, there still exist those with enormous fortunes who escape their tax responsibilities, while large sectors of the less fortunate population enjoy countless direct subsidies. As a consequence, the Brazilian middle class, as the essential motor of society, ever more fragile as it cannot avoid suffering the imminence of poverty and the inaccessibility of wealth, carries on its shoulders one of the heaviest tax burdens on the planet. Perhaps the return on those taxes, which for any Latin American seems obvious, given the general state of dilapidation in the rest of our countries, isn't enough for the Brazilians who religiously and inexorably must defray those costs.

But the unexpected Brazilian spring of protest cannot be satisfactorily explained so simply: during the past eighteen years, Brazil has enjoyed passable governors, many of whom were genuinely determined to defend freedom and overcome poverty; the society has opened exponentially, and consequently accusations and crimes that had remained hidden or gone unresolved in the past are now the object of public debate, often with much fanfare and scandal; Lula da Silva's government, having encouraged unparalleled social development, with a solid foundation in the reforms established by Presidents Itamar Franco and Fernando Henrique Cardoso, became at the same time one of the greatest corruption cases in Brazilian history; not to mention the dilapidated state of public morals and the abuse of majority power to the detriment of a truly deliberative institutional environment.

What are the Brazilian protestors saying? Are they speaking to us in some lingua franca, one all of us might understand? Is this a case of an eruption of the "political sublime," which is therefore unrepresentable until its catastrophic unruliness transforms history in an avalanche? Or perhaps by way of their street slogans Brazilians are speaking to us of that which persists, ever unrepresented and unrepresentable—precisely at that moment when political representation has managed to overcome its initial atavisms–and does not cease until it finds representation? One common feature of these protests lies in the fact that the protestors have taken on a questioning of the legislative function they are denouncing and thus, in passing, the secular inefficiency of Brazilian federal legislative power. In this way, the Brazilian protestors embody, perhaps for the first time in Latin America, a truly civic revolt that claims not power, but the law. Here, too, Brazil and its mass marches seem to offer something new.

But it's not as if simply by surprising us the protestors were announcing the apocalypse, as the media intrigue seems to suggest when they announce the end of the "Brazilian golden era." Mass protests like those that are taking place in Brazil are—or should be—the daily bread of any democratic society. They occur each year in France, in Italy, or in Spain, and no one announces the end of those nations. The international reception of the Brazilian protests has contributed to an array of confusions in the mainstream media, which questions not just the viability of Brazil's economic model, but alongside that, casts doubt upon the enormous preparations the World Cup and the Olympics demand, massively and imprudently, as the media questions the very possibility that Brazil might live up to its destiny in history. It may be that behind this irresponsible reception of Brazilian current events lurks something more serious, a Eurocentric and racist specter that constitutes the infantile illness of our nations.

In contrast to the Eurocentrism of the international mass media and Latin American (and hence Brazilian) elites, it's worth remembering Lezama Lima's furious response, in *La expresión americana (American Expression)*[2], in opposition to the racism exhibited by Hegel in his *Lectures on the Philosophy of History*, in which he contemplated Latin America—and especially its indigenous and Black elements—in terms of natural innocence, excluding it from the possibility of history. Such fundamental racism is still alive among us: its dense breath still clouds the vision of those opinion-makers who deny the condition of "pueblo" to the middle classes of developing countries. Its specter still survives in the petit-bourgeois European intellectuals who promote their theories of anguish and populism, protected from any experience of these by their academic ivory towers; its criminal drive still directs public policies that allow, as the images in this book clearly indicate, decisions to be made on behalf of others—always the same others, the powerless, the mestizos—to the detriment of their rights to place and to home, justified by "public policies" as abstract as they are indifferently bureaucratic.

It's a good idea, therefore, to remember two things: it seems that the planet as a whole is reaching saturation with the absurd consensus according to which the only possible politics are dictated by things—that is, by the state of the economy-and not by citizens; in the face of such a consensus, the solemn and hopeful phrase expressed by Emanuel Levinas in the dark year of 1934 will never cease to ring true: "Political freedoms do not exhaust the content of the spirit of freedom.[3]" This message—and none other—seems to be the one transmitted to us today to the rhythm of the samba and the slogans coming from the multitudinous avenues of the cities of Brazil, "lugar-nenhum dujo nome arde,"[4] as Caetano Veloso called it, with monumental presentiment, in his *Verdade Tropical*.

2 José Lezama Lima. La expresión Americana. Mexico: Fondo de Cultura Económica, 2005, p. 195.
3 Emanuel Lévinas. Les imprévus de l'histoire. Saint Clément de Rivière: 1994, p.29.
4 None-place with a burning name (trans. note).

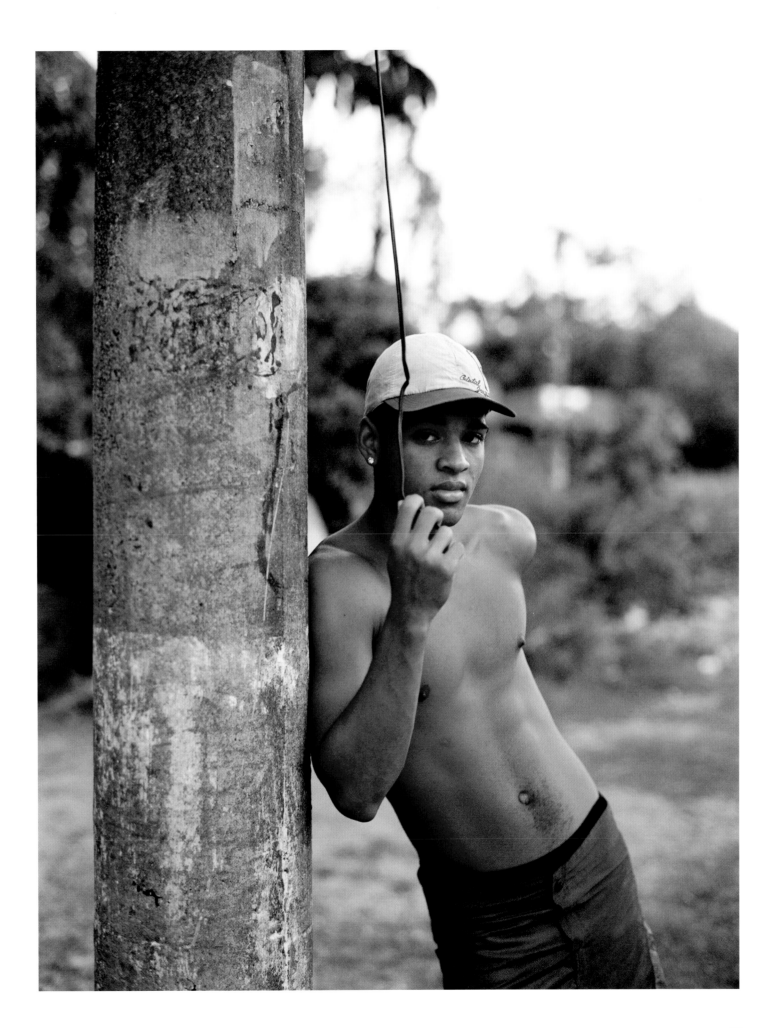

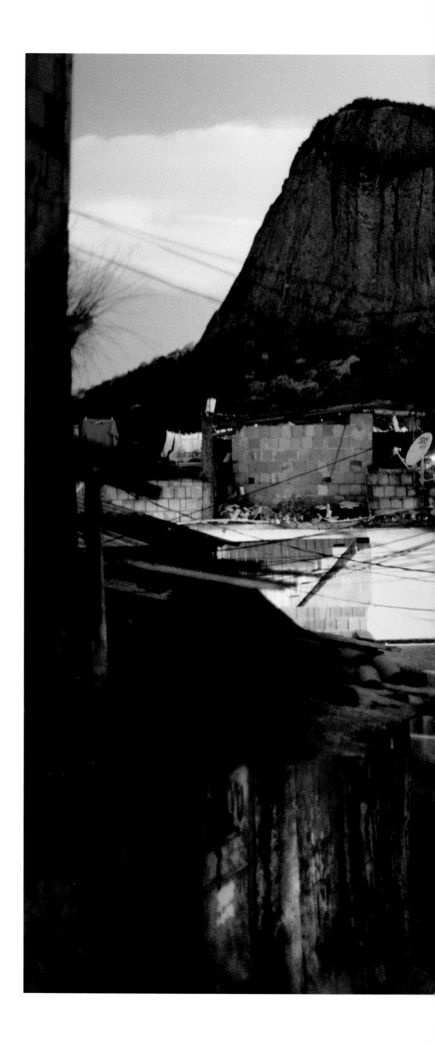

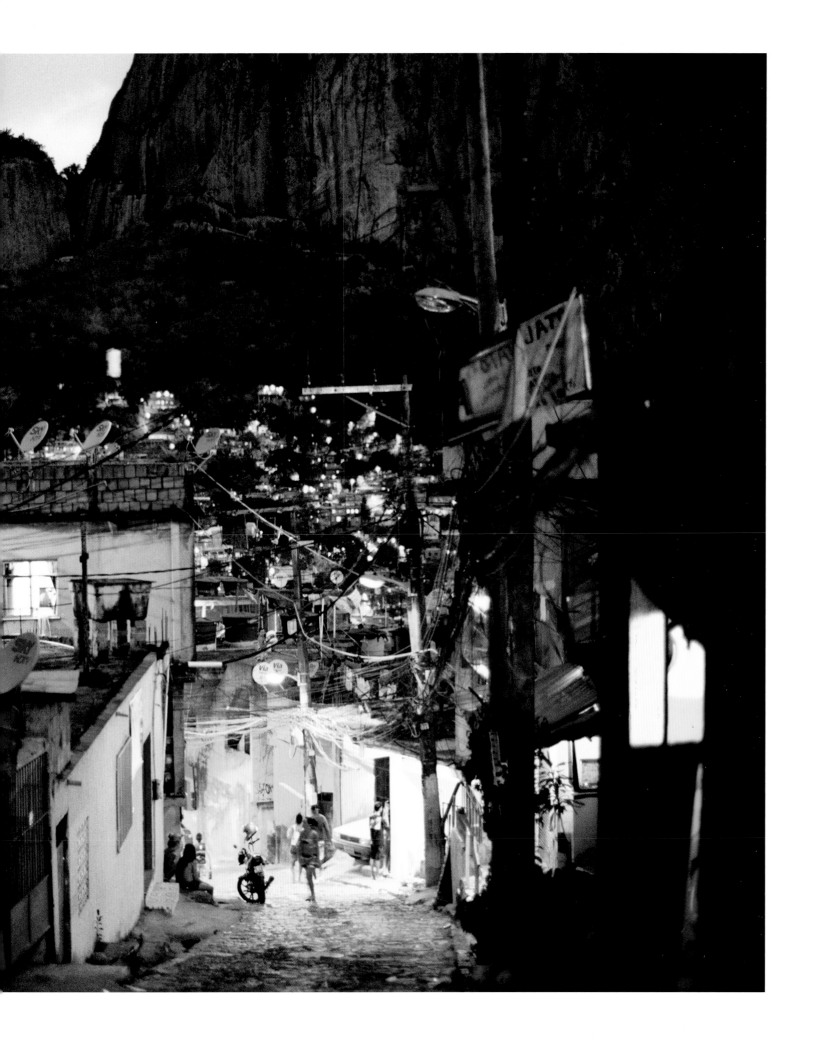

ACKNOWLEDGEMENTS

My gratitude for their inspiration, advice and practical help in making this work, and this book, to my creative family:

Rio de Janeiro:
Ana Rita Mendonça, Café Lima, Itamar Silva of *Ibase*, Ilda Santiago, Marcos Burgos, Theresa Williamson and Felicity Clarke of *Catalytic Communities.*

New York / Boston / Los Angeles / Geneva / Bologna:
Alex Galan, Allen Frame, Alexandra Leclef Mandl, Andrea Albertini, Bjarke Ballisager, David Kelley, Eva Lindemann, Fabian Bernal, Glenn Lowry, Guy Talley, Holly McWhorter, Jytte Jensen, Lee Means, Liz Brown, Luis Péréz-Oramas, Lorenzo Tugnoli, Mac Folkes, Marcos Chavez, Michael Nnadi, Nessia Pope, Pascale Willi, Paola Antonelli, Patty Chang, Eleonora Pasqui, Roxana Marcoci, Song Chong, Solomon Greene, Sue Simon, Tamer Agdas.

Mazie M. Harris curated the works for this edition. I am grateful that she shared her insight and reflections with me.

For their wonderful translations I thank Jen Hofer (Spanish text by Luis Peréz-Oramas) and Alex Forman (Portugese text by Itamar Silva).

I would like to thank Major Pricilla de Oliveira Azevedo of the Military Police in Rio de Janeiro for participating in the project. (Page 45)
Maj. Pricilla directed the first UPP unit (Unidade de Polícia Pacificadora) in Rio, with the goal of 'pacifying' Favela Santa Marta.
Implemented to date in many favelas, this strategy relies on the presence of paramilitary police units inside the favelas to push arms- and drug-trafficking out of the communities. In 2012, Major Pricilla was awarded the "International Women of Courage" Award by Hillary Clinton for her success in reducing violence in Rio's favelas.
Other officials I had invited to participate in the project declined, among them Pierre Batista, Secretary of SMH, and Carlos Nuzman, President of the Organizing Committee Rio 2016.

This book is dedicated to my love and inspiration, Rajendra Roy; and to my parents, Christine and Wolf Ohrem.

This map shows the approximate location of the 13 communities I worked in during 2012 and 2013:
Cantagalo, Pavão-Pavãozinho, Vila Autódromo, Estradinha, Tabajaras, Colônia J. Moreira, Morro da Babilônia, Chapéu-Mangueira, Realengo, Favela do Metrô, Morro da Providência, Santa Marta, Rocinha/Laboriaux.

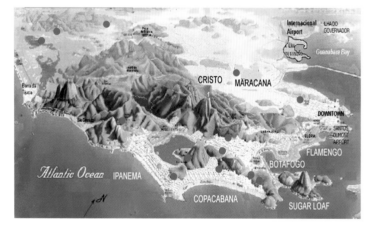

For more information and images visit www.olympicfavela.org and www.marcleclef.net.

Managing Editor: Alex Galán
Design and Layout Implimentation: Fabian Leonardo Bernal
All photographs Copyright 2014 Marc Ohrem-Leclef

Bologna - Italy
info@damianieditore.com
www.damianieditore.com

Copyright 2014 Damiani
ISBN 9788862083386

Printed in February 2014 by Grafiche Damiani, Italy